Large Art in Small Places

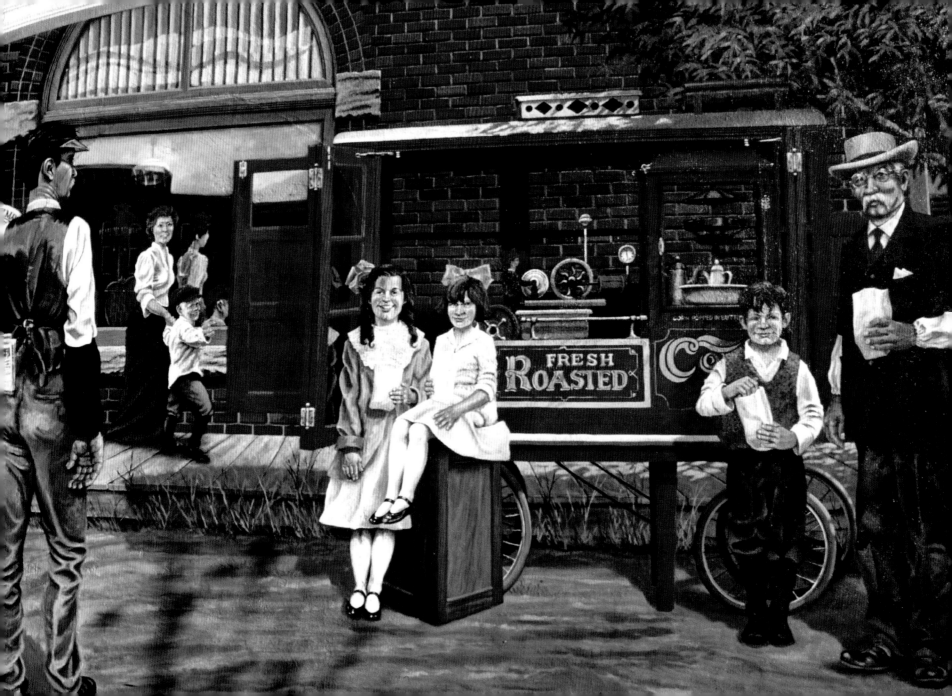

Large Art in Small Places

Discovering the California Mural Towns

Kevin Bruce

TEN SPEED PRESS
Berkeley | Toronto

To the dreamers and doers who have created the wonderful mural towns for us to enjoy and learn from, and to my fellow mural enthusiast, my wife, Pauline.

Ten Speed Press
PO Box 7123
Berkeley, California 94707
www.tenspeed.com

Distributed in Australia by Simon and Schuster Australia, in Canada by Ten Speed Press Canada, in New Zealand by Southern Publishers Group, in South Africa by Real Books, and in the United Kingdom and Europe by Publishers Group UK.

Cover and text design by Chloe Rawlins

See pages 181–83 for photo and text credits.

Library of Congress Cataloging-in-Publication Data

Bruce, Kevin (Kevin Ronald), 1941-
 Large art in small places : discovering the California mural towns / Kevin Bruce.
 p. cm.
 Summary: "Part art book, part travel guide, this is a colorful journey through twenty California murals towns"—Provided by publisher.
 ISBN 978-1-58008-880-0
 1. Mural painting and decoration, American—California—Guidebooks.
2. Small cities—California—Guidebooks. I. Title.
 ND2635.C2B78 2009
 751.7'309794—dc22
 2008033641

Printed in China
First printing, 2009

1 2 3 4 5 6 7 8 9 10 — 13 12 11 10 09

ACKNOWLEDGMENTS

Special thanks go to Bill Drennen, cofounder of the California Public Art and Mural Society for his inestimable help in organizing this project. Also, special thanks to Susan Bloch-Welliver and Richard Stenger for coordinating the Humboldt County mural towns and to Ben Trowell for creating the mural tour maps. The input of my editor, Lisa Westmoreland, made this book as readable and useful as possible. Thanks also go to all the dedicated members of the mural societies who give their time and skills to provide us the pleasure and enrichment of their wonderful murals. They furnished me with the vital ingredients from which this book was created. And finally, a big thank-you to Phil Wood of Ten Speed Press, who shares my love of murals and was a powerful driving force behind the creation of this book.

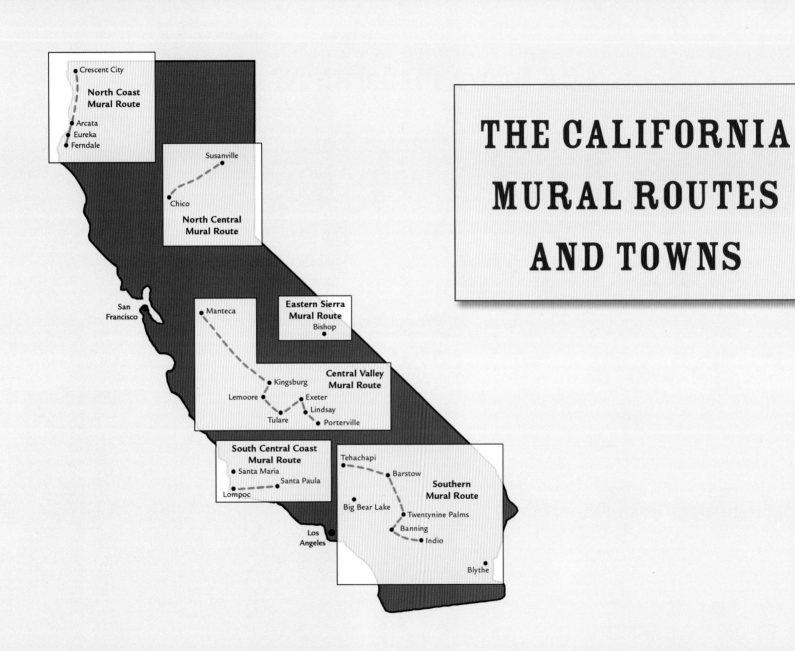

THE CALIFORNIA MURAL ROUTES AND TOWNS

North Coast Mural Route
- Crescent City
- Arcata
- Eureka
- Ferndale

North Central Mural Route
- Susanville
- Chico

Eastern Sierra Mural Route
- Bishop

Central Valley Mural Route
- Manteca
- Kingsburg
- Lemoore
- Exeter
- Lindsay
- Tulare
- Porterville

San Francisco

South Central Coast Mural Route
- Santa Maria
- Santa Paula
- Lompoc

Los Angeles

Southern Mural Route
- Tehachapi
- Barstow
- Big Bear Lake
- Twentynine Palms
- Banning
- Indio
- Blythe

CONTENTS

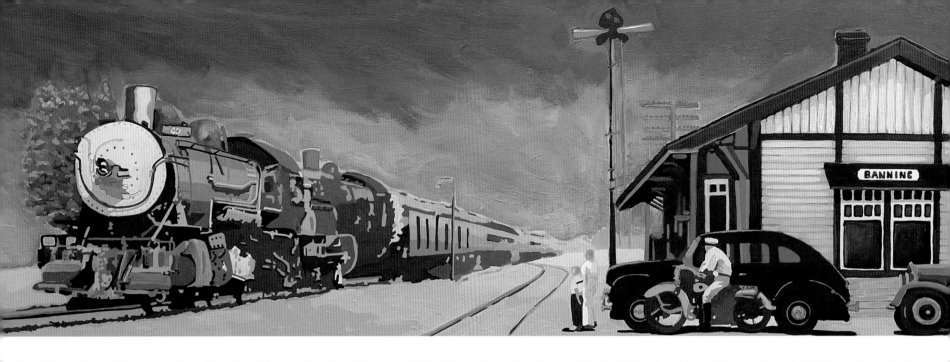

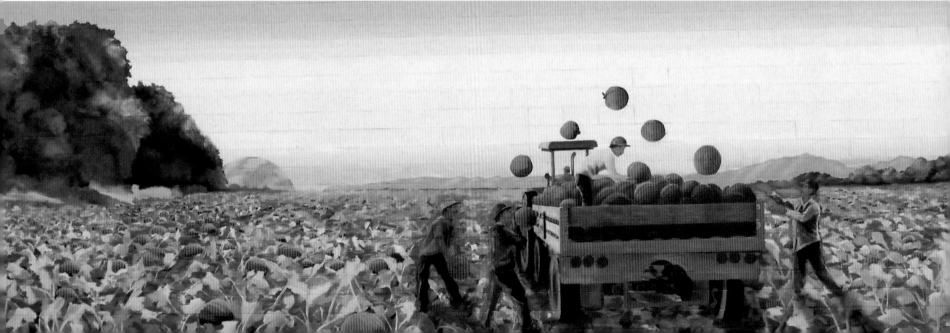

INTRODUCTION: THE MIRACLE OF THE CALIFORNIA MURAL TOWNS

California has always been in the cultural avant-garde. The state's major metropolitan areas, Los Angeles, the San Francisco Bay Area, and San Diego, are hotbeds of mural creativity. Diverse cultural, political, economic, and sometimes purely artistic influences have helped create and nurture cutting-edge murals of all styles and persuasions.

Over the past two or three decades, the growth of murals in small-town California has been especially phenomenal. There are a few essential reasons for the strong appeal of public murals in small towns. Lacking big-city sensory overload, small towns have fewer elements that compete for aesthetic attention, and a large-scale mural becomes a focal point of the community. The keen interest in murals has also been bred by the necessity of survival. Small towns are hubs of economic activity, but in some cases, the main sources of economic wealth have diminished drastically. A primary cause is often the failure of a core industry. Logging

operations cease, mines peter out, or key industries relocate. In response, some towns have created mural programs as a means of attracting visitors and revitalizing the economy through tourism.

An added bonus is a reinvigoration of civic pride. Many murals offer wonderful lessons about a town's past. Each town has a unique history, with heroes (and, for honesty's sake, a few villains), triumphs, and tragedies. What better way to share, and to learn about, small-town life than through the visual history lessons on the walls.

Whatever the reasons a small community initiates a mural program, the community finds that the rewards are numerous and more far-reaching than merely beautification or tourism. Muralist Don Gray comments on this aspect:

Many of the mural projects that spring up all over are in small towns that find themselves faced with lethargic economies. A mural program is proposed as a way to bring visitors (and their money) to town. A core group of energetic folks gets the ball rolling. Then an interesting thing happens. Friendships flourish

Murals, previous page: (top) *Banning Depot*, page 166, (bottom) *Pumkin Harvest*, page 59.

as activists rub shoulders to choose mural themes, meet artists, hold fundraisers, prepare walls for painting, and attend to the countless details that arise. The enthusiasm is contagious. More and more volunteers jump in. Suddenly, all this shared energy blossoms into a renewed sense of community pride that can't be measured simply in economic terms. They are revitalized in spirit as well. ★

Many observers consider the small town of Chemainus in British Columbia, Canada, to be the birthplace of what is called the mural town and Dr. Karl Schutz to be the chief architect. The Chemainus mural program began in 1982, and now this historic lumber-mill town boasts more than thirty large-scale murals. As a measure of the economic potential of a mural program, this town of three thousand residents attracts more than four hundred thousand visitors each year. Schutz's credo is "Never let those who say it can't be done stand in the way of those who are doing it." Acting as a consultant to small-town mural programs, he has been instrumental in spreading the concept of the mural town, especially to receptive places in California.

California has its own strong mural tradition that began in the 1920s and '30s. It was spearheaded by los Tres Grandes (the Three Greats): Diego Rivera, José Clemente Orozco, and David Alfaro Siqueiros. Their influence led to flourishing mural programs in large California cities, especially those with a sizable Hispanic population. They were closely followed by the Great Depression–era WPA murals in public buildings, and the tradition flourished through the social-action murals of the 1960s and '70s to a wide variety of mural projects being carried out today.

This is especially true in the small mural towns of California, where there has been an explosion of mural projects in the last ten years. Mural towns grow in many ways. Some small-town mural projects are the efforts of eager and prolific local mural artists. Although they become the core contributors, a project may expand by inviting out-of-town muralists to participate. Some mural towns begin as the work of a dedicated and inspired mural society, which raises money and commissions murals. However the mural program begins, it invariably incites community involvement and pride. One event designed to include the community in a hands-on manner is called mural-in-a-day. A master muralist is selected and given a theme, then researches the subject matter, designs a mural, creates a sketch on a prepared wall, and mixes the paint. Early on the appointed day, volunteers execute the mural in a paint-by-numbers fashion. At the end of the day, sometimes after sundown, the scaffolds are dismantled, the mural is signed by the participating painters, and the dedication is made. Photos

★ *Lindsay Mural Society Promotional Brochure,* 2005.

are taken, T-shirts and certificates are handed out, and everyone celebrates a job well done. This collaborative process not only reduces the cost of the mural through the use of volunteer efforts, but also fosters enthusiasm for the mural project within the community. Trompe l'oeil muralist John Pugh has firm ideas on the effect of public murals on small-town communities:

> *Murals help to create a sense of community pride and enthusiasm. Murals also help to establish a community identity. They unite people . . . bring people together. Public art can provide a sense of common history, common culture, and heritage. People underestimate the power of public art. It is an art that people can participate in and interact with.* ★

The growth of small-town mural projects is not limited to California. An increasing number of towns in the United States and Canada have embraced the mural town concept, and flourishing mural towns are found around the world, from Prestongrange, Scotland, to Sterling, Tasmania.

As this book defines a mural town, it is a place where the town intends the murals be all, or part, of a plan to attract tourism. Therefore, the murals are an economic drawing card as well

as an aesthetic novelty. Several "mural towns" have only one or two murals. These are budding mural towns in the first stages of their growth. They have mural societies in place and are planning to build mural collections as an integral part of their tourism appeal. They may not merit a special trip but are certainly worth a look if you happen to be nearby.

In selecting murals for the book, I have chosen murals by both amateur and professional artists and works offering a wide range of artistic appeal, from skillful narratives to expressions of pure whimsy. Masterworks of the genre include the trompe l'oeil narrative illusions of John Pugh, the larger-than-life epics of Wei Luan, the expressive portraits of Don Gray, and the dramatic historic tableaus of Art Mortimer. Countless murals by other artists add local flavor, unique perspectives, and individual styles. The captions are meant to give not only information about the mural, artist, and location but also a sense of the significance of each mural—what it contributes to the town and what makes it special. The standard medium for outdoor murals is acrylic paint, as it is the most durable and weatherproof medium. It is also less expensive and quicker to dry than oil-based paints. By their very nature, murals, placed on the sides of buildings, are generally large, some over one hundred feet in length. Whatever the medium, size, and inspiration, one thing is certain: these muralists have truly taken the museum to the streets.

★ John Pugh, interview by Kevin Bruce, 1998.

Your Guide to Artful Adventure

The mural towns of California offer a treasure trove of history and art. If you find art and history both enlightening and entertaining, this combination travel guide, art reference, and history book is the perfect resource—whether you make a weekend tour to several mural towns or visit just one mural town en route from one place to another.

Descriptions of each town and its attractions will help you plan your trip, but be sure to contact the local chamber of commerce (using the addresses, phone numbers, and websites provided) for current maps, calendars of events, restaurant and accommodation listings, and other information. The chambers can also provide you with additional background on the artists. Individual muralists' websites are another good source of information.

This book encourages travel at a slower pace. Mural towns are places where you can take your time and recharge your batteries. You will meet new people and enjoy leisurely small-town life out of the fast lane, and you will find much to learn.

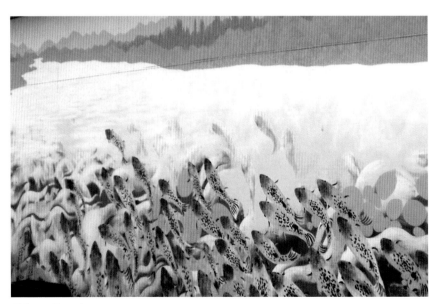

Salmon Run, Arcata.

1 NORTH COAST MURAL ROUTE

Crescent City · Arcata

Eureka · Ferndale

CRESCENT CITY

Crescent City / Del Norte County Chamber of Commerce
1001 Front Street, Crescent City, CA 95531
(800) 343-8300
www.delnorte.org · www.northerncaliforina.net

Crescent City, whose name is derived from the shape of the bay where the town is located, is in Del Norte County, in the far northwest corner of California. About 80 percent of the county is public land that protects dramatic coastline, pristine rivers, and redwood forests. A number of Native American groups have lived in the region for thousands of years. The town's modern history dates to the arrival of explorer Jedediah Smith in 1828. Crescent City has been an important logging, fishing, and shipping center ever since.

The Redwoods Mural Society was established to guide the community in adding at least one major mural each year that depicts the area's cultural heritage and natural wonders.

The Crescent City Murals

1: St. George Lighthouse
2: Point St. George Lighthouse
3: Battery Point Lighthouse
4: View of Crescent City
5: Crescent City's Lighthouses
6: Life Cycle of the Salmon
7: Mermaid and the Orca
8: The Return of the Yurok
9: Beachfront Park
10: Jack London Visits X. A. Phillips Store
11: Redwood Elk
12: Jedediah Smith

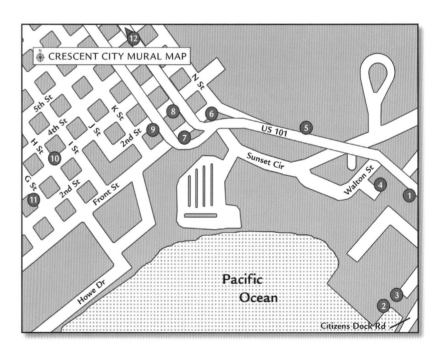

1. St. George Lighthouse *(top)*

Lighthouse Inn, 681 Highway 101 South, Rick Chambers, 2002

Since Crescent City is a thriving port, the lighthouse, dating from 1892, has always been important. Here, the keeper rows in rough seas as he returns to the lighthouse.

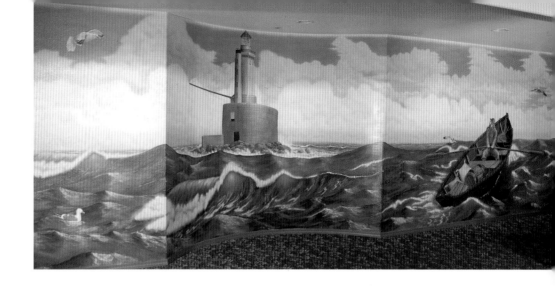

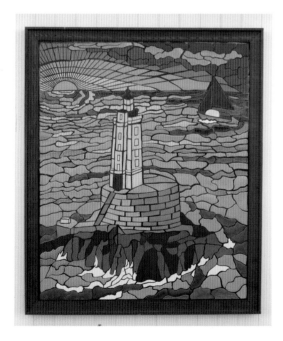

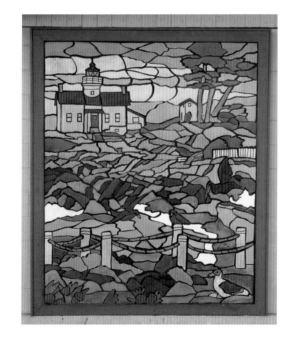

2. Point St. George Lighthouse *(bottom left)*

Harbor District Office, Crescent City Harbor, Harley Munger, 2006

This ceramic puzzle mural depicts the lighthouse in an intriguing stylized manner. Harvey Munger and his wife, Jill, are the founders of Elk Valley Artisans, a group dedicated to the arts and education.

3. Battery Point Lighthouse *(bottom right)*

Coast Guard Auxiliary Hall, Harley Munger, Virginia Brubaker, 2005

The Department of Mental Health and the Crescent City Harbor District sponsored this ceramic puzzle mural project. It was created with the help of youth through community service hours.

4. View of Crescent City *(top)*
Ocean World, 304 Highway 101 South, Rick Chambers, 2002

In this fanciful view of Crescent City's watery environs, an underwater scene on the left progresses into a dramatic seascape featuring sea lions on the rocks surrounding Battery Point and its lighthouse. A three-dimensional shark hanging above the tableau adds a realistic counterpart to its cousin in the mural.

5. Crescent City's Lighthouses *(bottom)*
255 Highway 101 South, Garetta Lamore, 2006

Creation of this mural was part of the 2006 yearlong sesquicentennial celebration of Battery Point Lighthouse. Also depicted is St. George Reef Lighthouse, eight miles offshore. Alan Justice took a photo of the view of both lighthouses. Using it as a reference, artist Garetta Lamore painted a prototype, which was used to complete the 127-by-14-foot mural in less than two months. Nearly one hundred novice painters were guided by local artists, primarily from the Crescent Harbor Gallery co-op.

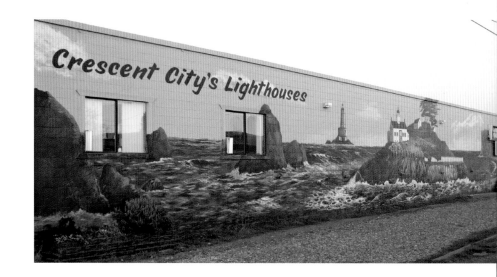

6. Life Cycle of the Salmon *(top)*

Rural Human Services Building, 286 M Street,
Harley Munger, Kristin Schimik, 2000

Youth from the Rural Human Service Youth Pottery Program created
this ceramic puzzle mural depicting the life cycle of the Pacific salmon,
a staple of the local economy.

7. Mermaid and the Orca *(bottom)*

Highway 101 and Front Street, Kathleen Kresa, 2006

Muralist Kathleen Kresa describes the energetic movement of her art best:
"The mural features a beautiful mermaid, her head thrown back in ecstasy,
riding the orca killer whale down through the depths of the kelp forest.
Sunlight filters through the waving kelp, highlighting the dancing leaves,
the mermaid's hair, and the jeweled scales of her tail."

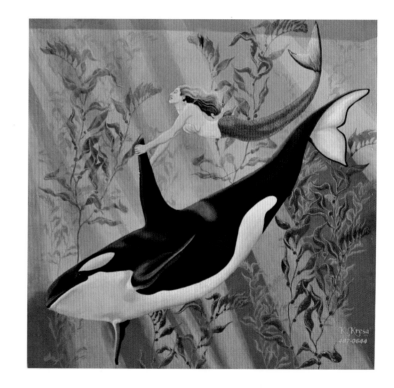

8. The Return of the Yurok *(top)*

Highway 101, Kathleen Kresa, 2006

Located sixty feet north of Kathleen Kresa's *Mermaid and the Orca*, this mural is a tribute to the commercial fishermen of Crescent City. Kresa based the painting on photographs of actual fishing boats.

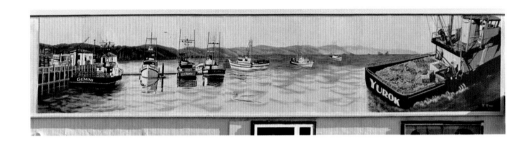

9. Beachfront Park *(middle)*

Social Service Building, Harley Munger, Virginia Brubaker, 2006

This three-panel ceramic puzzle mural, designed by Virginia Brubaker and supervised by Harley Munger, is an imaginative rendering of a popular local park. The mural was produced by youth in the Social Service's Independent Living Skills Program, supported by the Del Norte Department of Mental Health.

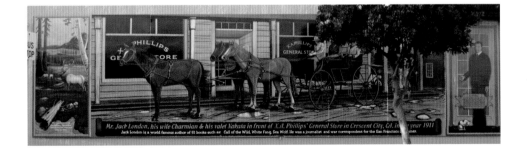

10. Jack London Visits X. A. Phillips Store *(bottom)*

312 H Street, Warner J. Ramey, 2006

In 1911 Jack London and his party stopped in Crescent City on their travels through northern California and southern Oregon. This trip was the source for London's "Four Horses and a Sailor," published in *Sunset* magazine. X. A. Phillips, an astute local businessman and owner of Phillips Mercantile on Second Street, asked London to pose in front of his store for a photo. The Del Norte Historical Society made the photo available to the Gateway Partnership, which funded the painted plywood mural.

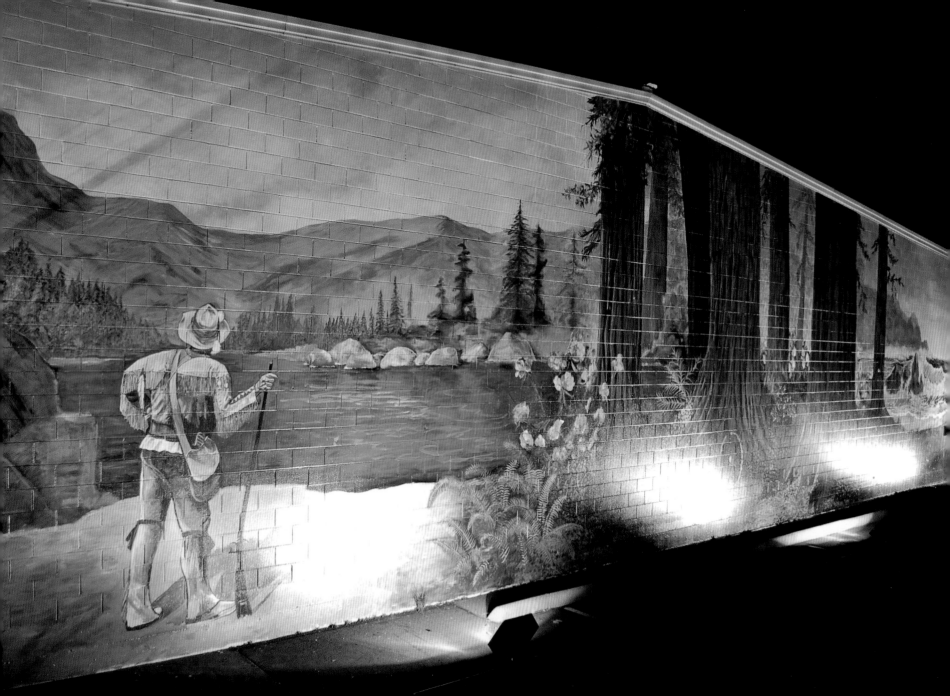

11. Redwood Elk *(above)*

Crescent City Library, 190 Price Mall, Kathleen Kresa, 2006

Bull Roosevelt elk are the centerpiece of a mural that depicts the giant redwoods and lush vegetation typical of the northern California coast.

12. Jedediah Smith *(previous page)*

Ace Hardware, 840 E. Washington Boulevard, Doris Dalbec, 2007

Jedediah Smith, the renowned mountain man, explored the length and breadth of California. Doris Dalbec designed the mural and created it with the assistance of more than fifty local volunteers.

OTHER THINGS TO DO

· Jedediah Smith Redwoods State Park: Hike amid giant redwoods in this accessible wilderness setting.

· Smith River and Klamath River: These pristine rivers are prime fishing waters for steelhead and salmon.

· Annual Events: Time your mural tour so you can participate in the many annual events in the area, from fishing derbies and crab races in early spring to surfing competitions and classic car shows in the fall. See the chamber websites for details.

ARCATA

Arcata Chamber of Commerce
1635 Heindon Road, Arcata, CA 95521
(707) 822-3719
www.arcatachamber.com

Arcata, a Native American word meaning "a place to land," was an instrumental supply source for prospectors in the area. Lumber and fishing also contributed to the town's economy. Now, as in the past, the heart of Arcata is the Plaza, which is lined with boutiques, eateries, bookstores, and coffeehouses, and is the location of community events. The area around the Plaza has many restored Victorian homes.

Arcata's mural program, begun in 1991, has steadily grown to include almost a dozen murals that depict the history and ambiance of this college town on Humboldt Bay.

The Arcata Murals

1: Salmon Run

2: Farmland Scene

3: 1912 Arcata Plaza Scene

4: Sea Life

5: Mythical Village Scene; Multicultural Neighborhood

6: The Road to Sustainable Street

7: Wilderness Scene

8: Life Through Time

9: Tyrannosaurus Rex

10: Vegetable Garden

11: Eureka Shipyard

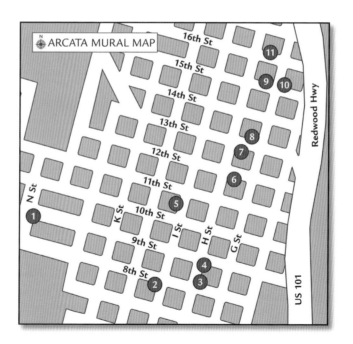

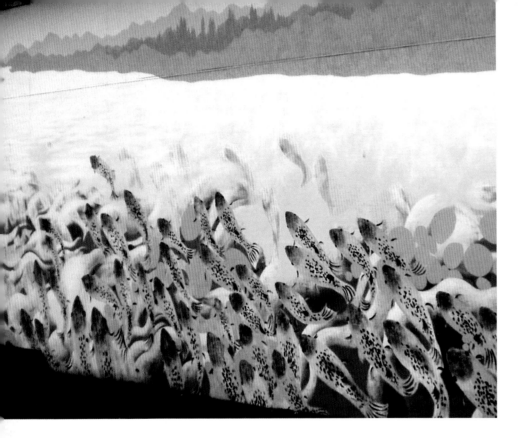

1. Salmon Run *(top)*

Arcata Community Recycling Center, 1380 Ninth Street, Thao Le Khac, 2002

Salmon are one of the mainstays of the local fishing industry. In this stylized mural, salmon swim upstream to their spawning grounds. Local students assisted muralist Thao Le Khac in the painting of the mural.

2. Farmland Scene *(next page)*

811 I Street, Duane Flatmo, 2000

The subject of the mural, a rural Humboldt farm, suits its location on the wall of the Arcata North Coast Co-op. The style contrasts with Duane Flatmo's trademark cartoon approach.

3. 1912 Arcata Plaza Scene *(bottom)*

Arcata Exchange/Furniture on the Plaza, 813 H Street, Jerry Lee Wallace, 2003

In 1912 Arcata was bustling with lumber mills that shipped timber from the town's deepwater port. The mural is based on a photo that can be seen at Hensel's Ace Hardware at 884 Ninth Street.

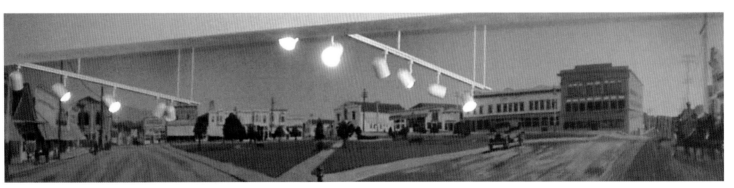

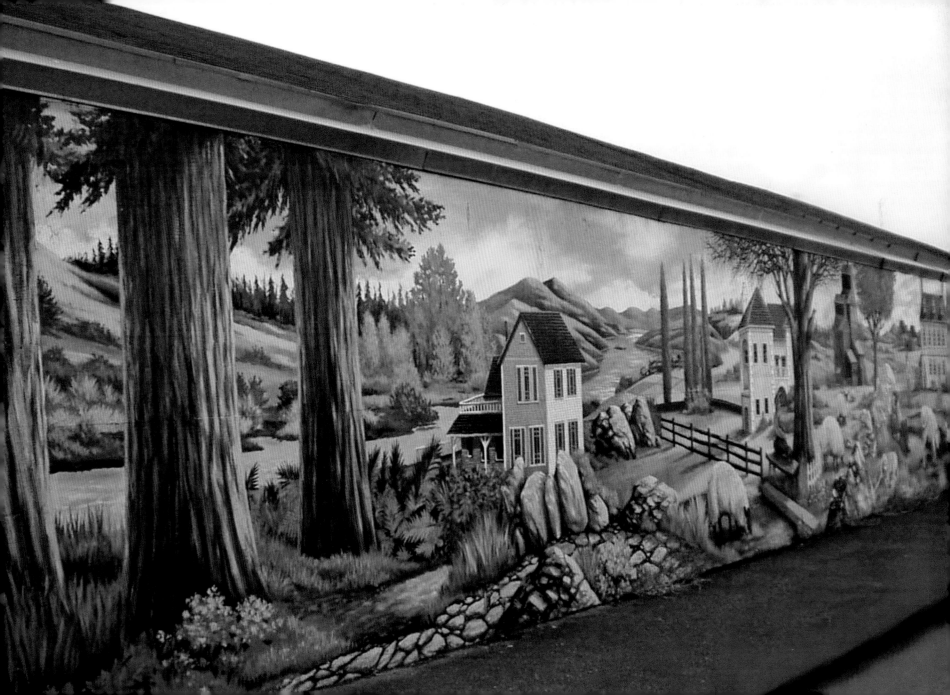

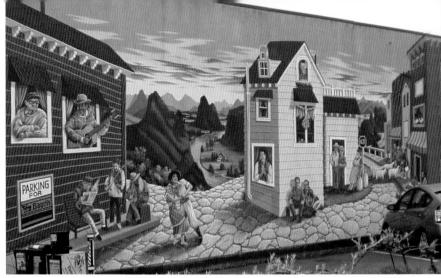

4. Sea Life *(top left)*

Arcata Stationers, 833 H Street, Vincent Callagher, 1995

The mural asks viewers to imagine they are in an aquarium tank. Vincent Callagher extended the painting onto the ceiling, which features the bottom of a passing boat.

5. Mythical Village Scene; Multicultural Neighborhood *(top right)*

1027 I Street, Duane Flatmo, 1995

The invented village scene includes actual Arcata residents and is rendered in Duane Flatmo's whimsical cartoon style.

6. The Road to Sustainable Street *(bottom)*

Twelfth Street between G and H Streets, City of Arcata, 2006

Local teens participating in the City of Arcata Recreation Division's Summer Youth Mural Project designed this mural to focus on the community's efforts towards a more eco-conscious lifestyle and completed the mural over a three-year span.

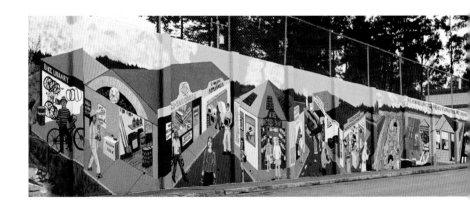

7. Wilderness Scene *(top)*

Wildberries Marketplace, 747 Thirteenth Street,
Jim and Shannon Childs, 1991

Wildberries Marketplace is a bustling neighborhood grocery, bakery, and coffeehouse. The mural celebrates the natural environment, in keeping with the market's emphasis on natural foods.

8. Life Through Time *(bottom)*

Humboldt State University Natural History Museum, 1315 G Street,
Treena Joi, 1996

Treena Joi, a work-study student and a biology major, based the creatures in the mural on fossil specimens in the museum's collection.

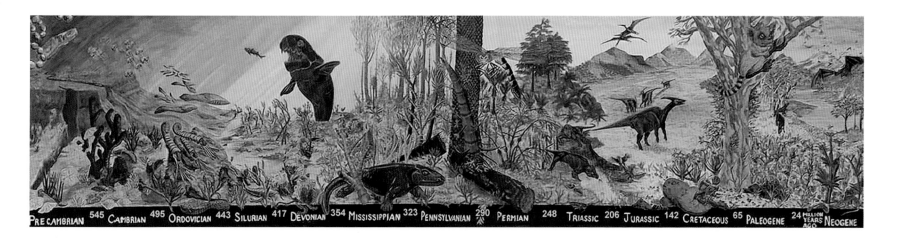

PRE CAMBRIAN 545 CAMBRIAN 495 ORDOVICIAN 443 SILURIAN 417 DEVONIAN 354 MISSISSIPPIAN 323 PENNSYLVANIAN 290 PERMIAN 248 TRIASSIC 206 JURASSIC 142 CRETACEOUS 65 PALEOGENE 24 MILLION YEARS AGO NEOGENE

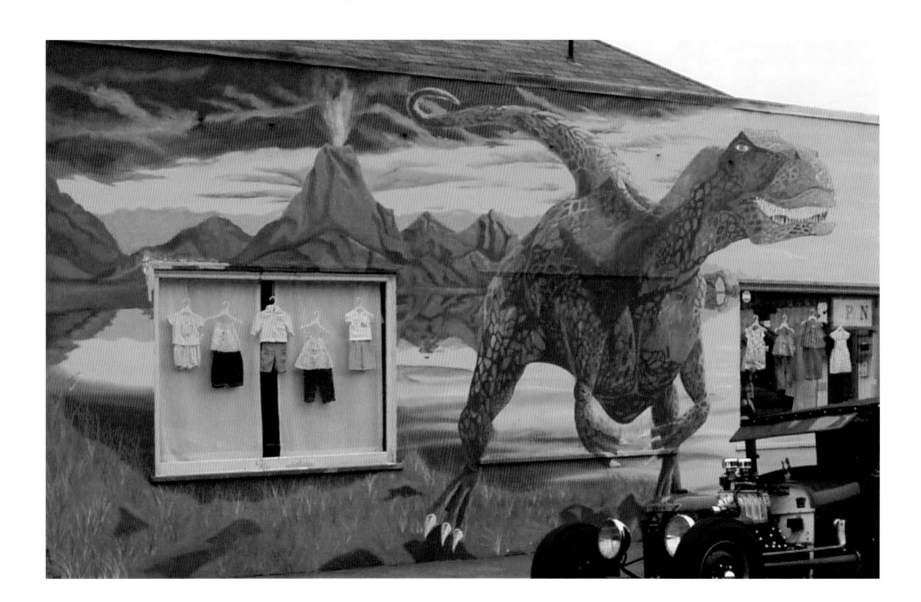

9. Tyrannosaurus Rex *(previous page)*
20' x 16', 1507 G Street, Leon Martin, 2000

The menacing *T. Rex* lunging from the volcanic landscape is a favorite with kids.

10. Vegetable Garden *(top)*
Japhy's Soup and Noodles, 1563 G Street, Thao Le Khac, 1996

Restaurant customers are transported to a fanciful verdant garden with oversized fruits and vegetables.

11. Eureka Shipyard *(bottom)*
750 Sixteenth Street, Duane Flatmo, 1996

This mural makes vivid the sailing ships that once frequented the bustling Arcata harbor carrying lumber from the local mills and bringing in supplies to the gold miners on the Trinity River.

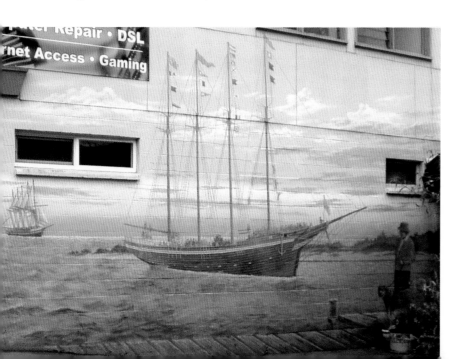

OTHER THINGS TO DO

· Arcata Marsh and Wildlife Sanctuary: The sanctuary, a wastewater reclamation system, is a wildlife habitat and offers trails ideal for bird-watching.

· Humboldt State University Natural History Museum: The museum has an extensive fossil collection and exhibits of California fauna and flora.

· Victorian Homes Tour: This self-guided tour can be taken concurrently with the mural tour. Obtain a map at the Arcata Chamber of Commerce.

· Arcata Community Forest and Redwood Park: The two adjacent parks, totalling over 800 acres, offer trails for hiking and biking.

EUREKA

Humboldt County Convention and Visitors Bureau
1034 Second Street, Eureka, CA 95501
(800) 346-3482
www.redwoods.info

The Eureka Murals

1: Food for People
2: People Served by Humboldt Family Services
3: Go Fish
4: North Coast Co-op
5: No Barking Any Time
6: Inharmonious
7: The Sun Set Twice on the People That Day (Indian Island)
8: Alley Cats
9: The Performing Arts
10: The Grand Performance
11: Post Office Alley
12: The Gray Victorian
13: Animals Are People Too
14: Murray Field Vintage 1930

Eureka, located on Humboldt Bay, has long been a timber, fishing, and shipping center. The once-wild waterfront retains many reminders of the town's bustling past, including magnificent houses built from local redwood. The downtown area, or Old Town, has restored vintage commercial buildings that house bookstores, restaurants, coffeehouses, galleries, museums, and boutiques.

Eureka enjoys a reputation as an art center. The mural scene is vibrant as well. Eureka artist Duane Flatmo, the most prolific muralist, has taught local youth the art of mural painting. Several murals have been completed by area high school and college students under the aegis of the Rural Burl Mural Bureau.

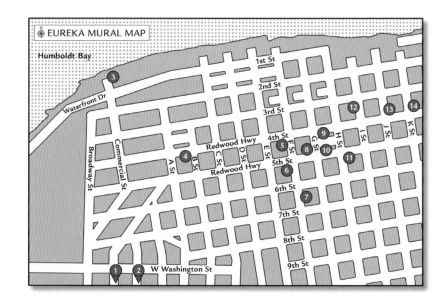

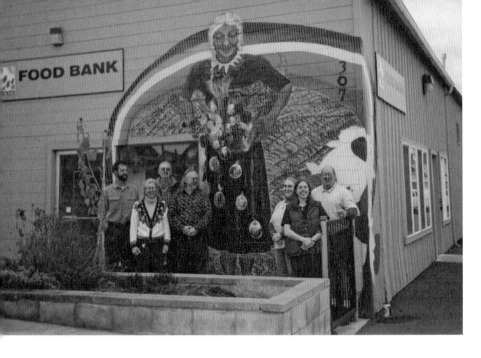

1. Food for People *(top)*

Food Bank, 307 W. Fourteenth Street, Donvieve, 2000

Mother Earth, backed by a rainbow, holds a cornucopia, the perfect image for the Eureka Food Bank. Students from Zoe Barnum School helped complete the mural.

2. People Served by Humboldt Family Services *(bottom right)*

Humboldt Family Services, 1802 California Street, Donvieve, 2000

This mural salutes the area's diversity and the quest for cooperation. Native American artists from Humboldt Bay School assisted the muralist.

3. Go Fish *(bottom left)*

Go Fish and Chips Café, 31 Commercial Street, Augustus Clark, 2006

The whimsical mural is an example of the colorful and fanciful works of Augustus Clark, who also makes assemblages and detailed drawings in varied media.

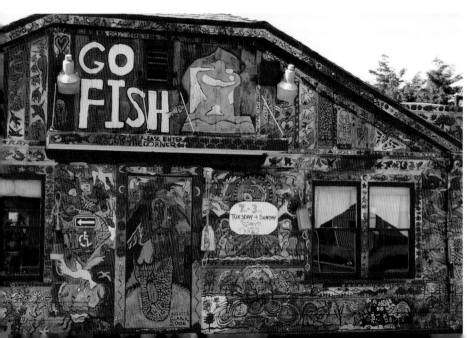

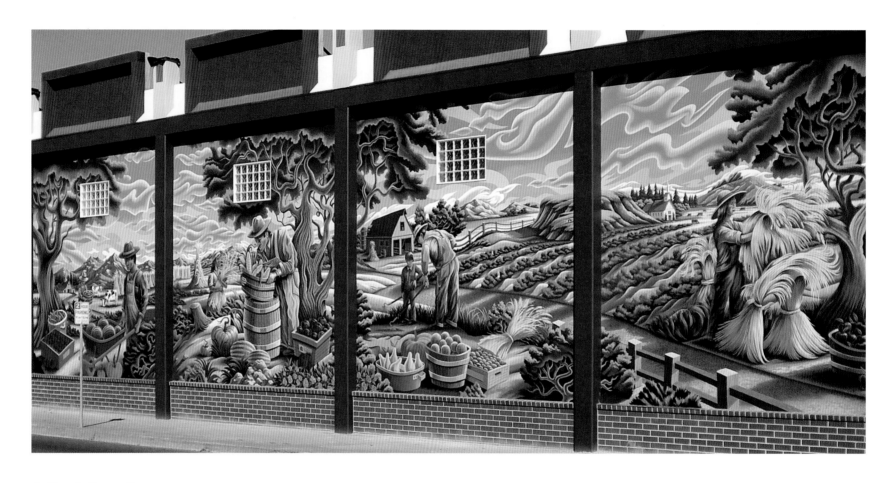

4. North Coast Co-op

120' x 20', 25 Fourth Street, Duane Flatmo, 2006

Duane Flatmo's depiction of a farm family and their harvest recalls the
style of Midwest regionalists of the 1930s such as Grant Wood and
Thomas Hart Benton.

5. No Barking Any Time *(top left)*

40' x 15', North Coast Dance Studios, 426 F Street, Duane Flatmo, 1993

Duane Flatmo designed the cartoon canine scene and worked with Rural Burl Mural Bureau students to complete it.

6. Inharmonious *(top right)*

120' x 8', 520 F Street, Duane Flatmo, 2003

Duane Flatmo comments on the seeming incompatibility of rural folk and city dwellers, executed with assistance from the Rural Burl Mural Bureau.

7. The Sun Set Twice on the People That Day (Indian Island) *(bottom)*

Between Eureka Theatre, 612 F Street, and Morris Graves Museum of Art, 636 F Street, Brian Tripp and Alme Allen, 2000

This first Native American mural in Eureka was commissioned by the Original Voices, dedicated to the preservation and teaching of indigenous knowledge and culture.

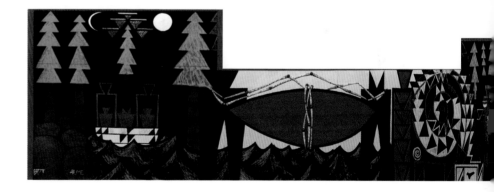

8. Alley Cats *(top)*

25' x 15', Living Light Center, G Street between Fourth and Fifth Streets, Duane Flatmo, 1994

Felines receive the Duane Flatmo touch, assisted by the Rural Burl Mural Bureau. As with their canine counterparts, it is assumed that this depiction of unconstrained alley cat conviviality is probably not encouraged. But cats will be cats.

9. The Performing Arts *(bottom)*

70' x 70', G Street between Fourth and Fifth Streets, Randy Spicer, 2006

A homage to the performing arts, the mural represents dance, theater, and even the circus.

10. The Grand Performance *(next page)*

Arkley Center for the Performing Arts, 412 G Street, Duane Flatmo, 2007

Duane Flatmo's versatility extends to trompe l'oeil. Here, a dancer emerges from the Arc de Triomphe, accompanied by two musicians and a conductor.

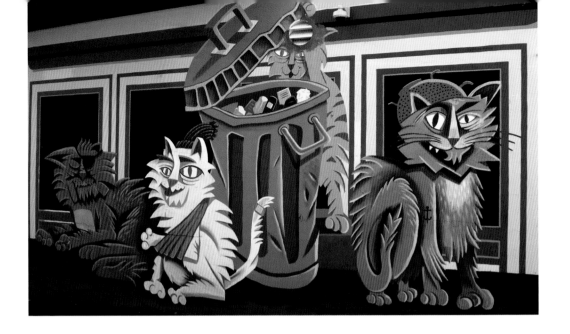

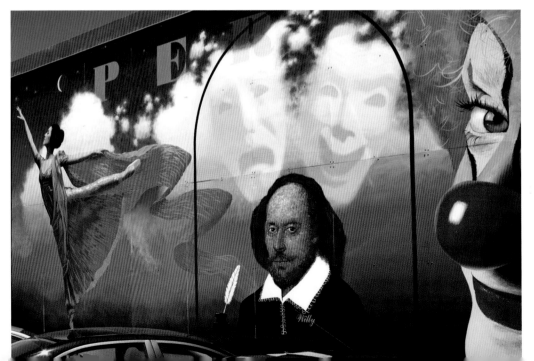

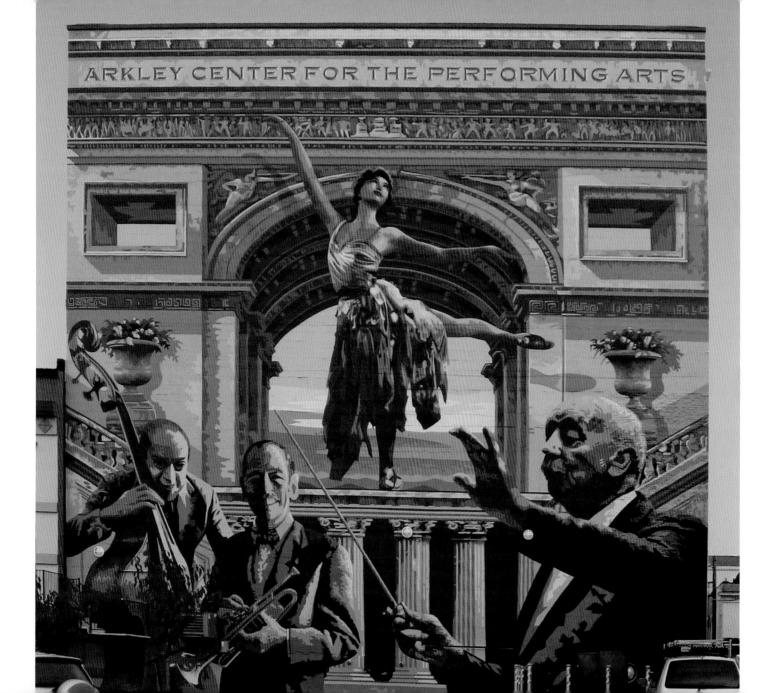

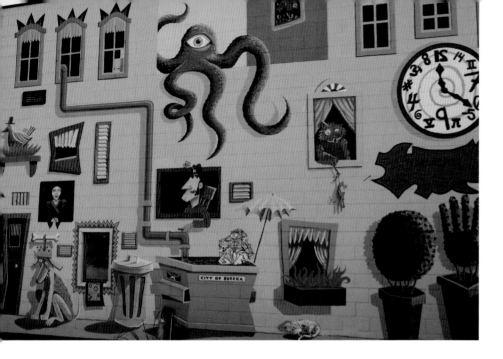

13. Animals Are People Too *(bottom)*

100' x 20', Courthouse Market, 905 Fourth Street, Duane Flatmo, 2004

While putting the finishing touches on the lion in royal attire, Katie Texas came up with the title for the eighty-by-fifteen-foot mural, which was prompted by the brutal killing of dogs in Blue Lake. Once again, Duane Flatmo worked with the Rural Burl Mural Bureau.

11. Post Office Alley *(top left)*

130' x 20', Main Post Office, Fifth and H Streets, Duane Flatmo, 2003

In this mural, Flatmo creates an impossible world for the viewer to enjoy: an octopus on the roof, a man with a bird on his head, water flowing from a second story window, and a clock with whimsical numbering are just a few of the strange depictions in this bizarre narrative.

12. The Gray Victorian *(top right)*

100' x 10', Times Printing, 723 Third Street, Duane Flatmo, 1997

The mural on the one-story building in the foreground blends into the adjacent Victorian house, creating the illusion of a large building. Footprints in the parking lot indicate the best place to stand for viewing the mural. For the project, Duane Flatmo worked with Rural Burl Mural Bureau students.

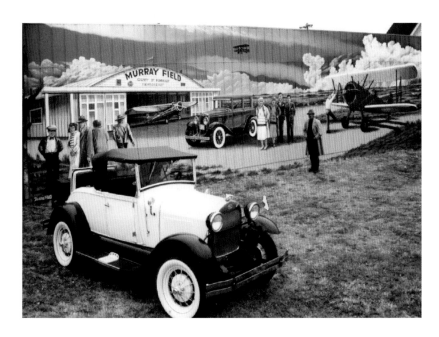

14. Murray Field Vintage 1930

60' x 15', Eureka Travel, 1103 Fourth Street, Duane Flatmo, 1989

This mural depicts an early scene of old Murray Field, the local 1930s small-craft airport, with vintage airplanes being readied for takeoff. The mural incorporates the grass growing next to the building into the scene on the wall. The classic car and the trench-coated man in front blend in perfectly.

OTHER THINGS TO DO

· Samoa Cookhouse: Established in 1893, this is the last lumber camp–style cookhouse in the West.

· Carson Mansion: The ornate Victorian mansion dates from 1886 and is considered to be the most photographed Victorian in the United States.

· Sequoia Park and Zoo: The tract of old-growth redwoods in south Eureka has nature trails, a duck pond, two playgrounds, and a charming small zoo perfect for children.

· Fort Humboldt State Historic Park: This overlooked treasure has reconstructed army buildings from the mid-1800s, one with an excellent museum.

· Morris Graves Museum of Art: This museum is dedicated to the arts and artists of the Pacific Northwest.

· Annual Events: Time your mural tour to coincide with annual local events. Highlights include a kinetic sculpture race on Memorial Day, an open studio tour in June, and the monthly Arts Alive Walk. See the chamber website for more information.

FERNDALE

Ferndale Chamber of Commerce
PO Box 325, Ferndale, CA 95536
(707) 786-4477
www.victorianferndale.org

In the late 1800s, Ferndale blossomed as the dairy center of northern California. By 1890, eleven separate creameries were operating in the immediate area. Ferndale butter was considered the finest in the state, bringing premium prices in San Francisco, and the town acquired its first nickname, "Cream City." During this period Ferndale became a melting pot of Scandinavian, Swiss-Italian, and Portuguese immigrants.

The Victorian Village of Ferndale has avoided urban sprawl and in many ways has remained unchanged since the 1800s. The town has many splendidly ornate commercial buildings and churches and an array of elegant homes, aptly called Butterfat Palaces. In fact, Ferndale has been dubbed the "best preserved Victorian village in California" by *Los Angeles Times* travel editor Jerry Hulse.

The Ferndale Murals

1: Ferndale Museum
2: African Wildlife

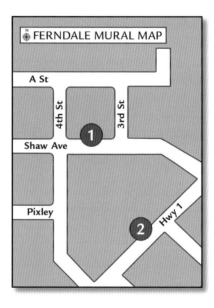

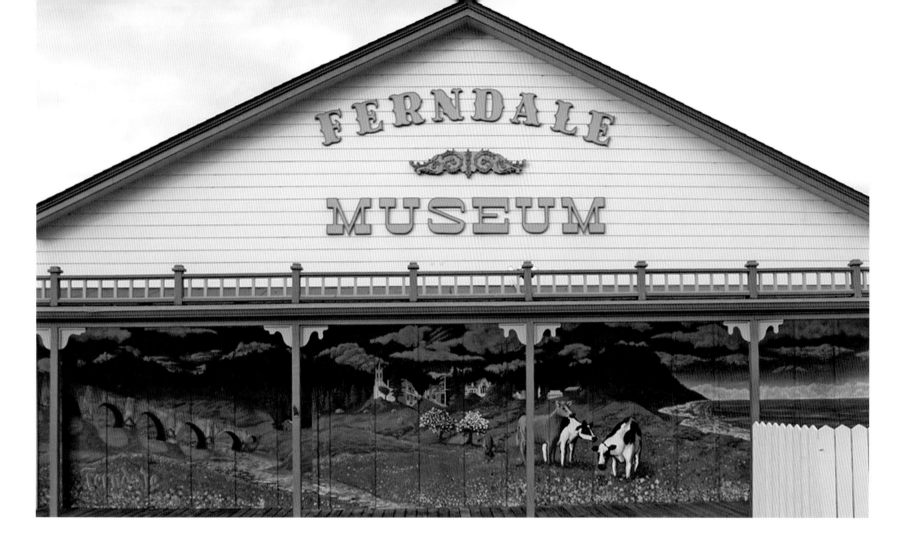

1. Ferndale Museum
515 Shaw Avenue, Empire Squared, 2003

Empire Squared, an Eureka-based art group, donated the labor to create this mural containing key icons of Ferndale, including the approach to the town over the Eel River via Fernbridge, which celebrates its hundredth anniversary in 2011. A lush pasture dotted with wildflowers leads to the Church of the Assumption, and the Pacific Ocean laps against Centerville Beach.

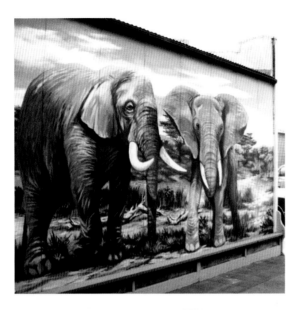

2. African Wildlife

468 Main Street, Duane Flatmo, circa 1990

A business called the African Connection originally occupied the building and commissioned this mural of an African landscape with roaming bull elephants.

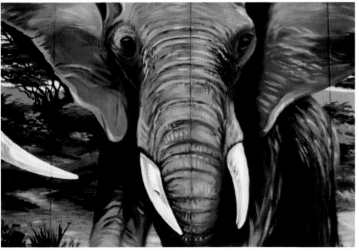

OTHER THINGS TO DO

· Fern Cottage: Built in 1866 for the cattle-ranching Russ family, the picturesque farmhouse is on the National Register of Historic Places.

· Ferndale Cemetery: With its many historic markers, the pioneer cemetery is a surprisingly popular attraction.

· Ferndale Museum: Victorian room settings, a working seismograph, and farming and dairy equipment are among the displays.

· Ferndale Kinetic Sculpture Museum: Imaginative people-powered sculptures from past Kinetic Sculpture Races are on view.

· Victorian Village Self-Guided Tours: Various businesses in town provide a free souvenir newspaper with maps and directions to historic homes.

2 NORTH CENTRAL MURAL ROUTE

Chico · Susanville

CHICO

Chico Chamber of Commerce
300 Salem Street, Chico, CA 95928
(530) 891-5556
www.chicochamber.com

Chico means "small" in Spanish but is hardly an apt description of the modern-day town, site of one of the California State University campuses, which contributes to the town's many cultural offerings.

Chico is situated in the heart of the Sacramento Valley, and the Sacramento River runs through town. Nuts of all kinds, from almonds to walnuts, are grown on the surrounding farms. Sierra Nevada Brewery, one of the largest independent breweries in the United States, is located in Chico and has a notable mural. The town has a vibrant art community.

1. Academe (next page)
Taylor Hall, First and Salem Streets, John Pugh, 1981
John Pugh, known for his masterful trompe l'oeil painting, created this landmark mural when he was a student at Chico State. The columns revealed by the broken wall are a comment on the roots of the Western education system in ancient Greece.

The Chico Murals

1:	Academe	7:	Town Hall 1872
2:	State Normal School	8:	Trolley
3:	Bidwell's Flour Roller Mill	9:	Space Walker
4:	Windows	10:	Abbey Road
5:	Annie and John Bidwell	11:	White Birches
6:	Sherwood Forest	12:	Sierra Nevada Brewery

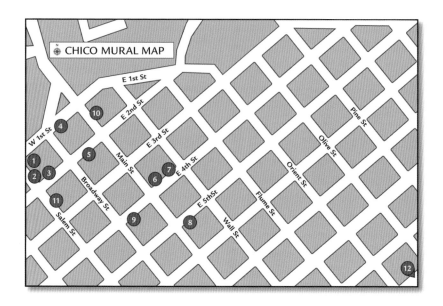

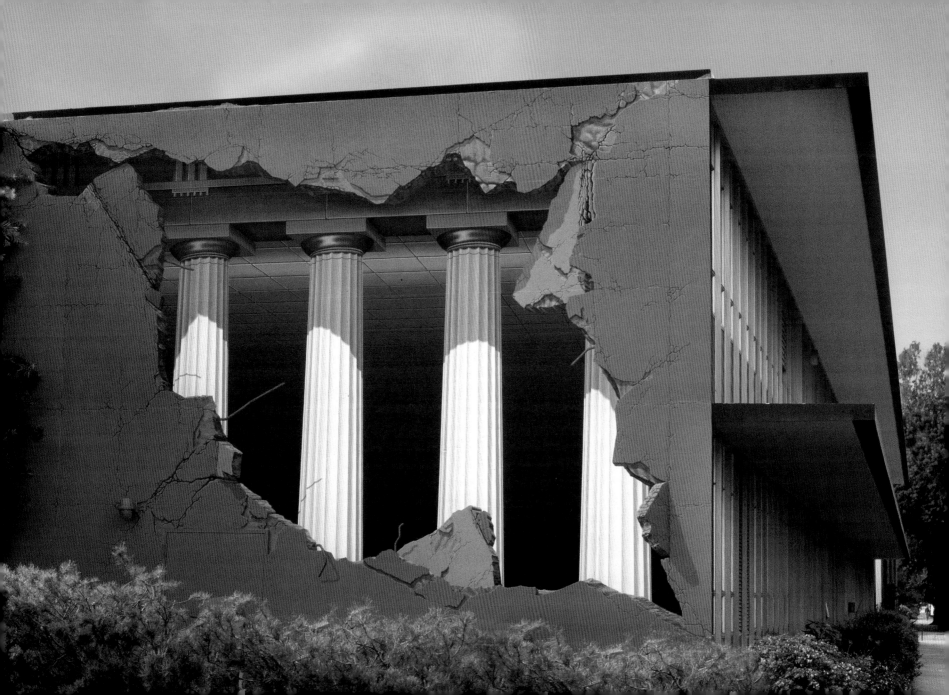

2. State Normal School *(right)*

Chico Museum, 141 Salem Street, Scott Teeple, 2006

The painted panels, placed over windows that had been covered with plaster for many years, show the original State Normal School, a teacher's college, which burned down in 1927. The school was once across from this wall in the space that is now occupied by Chico State.

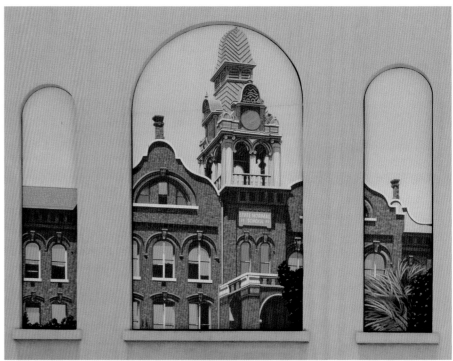

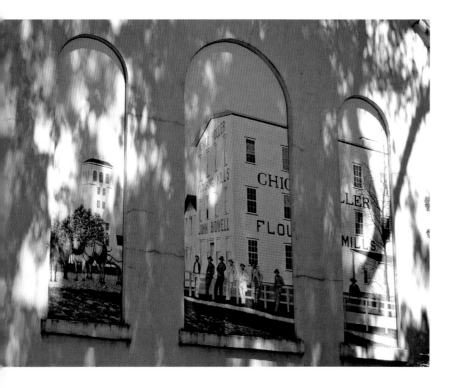

3. Bidwell's Flour Roller Mill *(left)*

Chico Museum, 141 Salem Street, Scott Teeple, 2007

The flour mill, which burned in the early 1960s, was situated on Big Chico Creek across from the historic Bidwell Mansion. The mural includes detailed likenesses of eight locally known characters from the late 1800s.

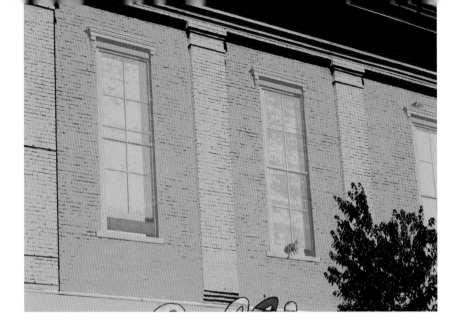

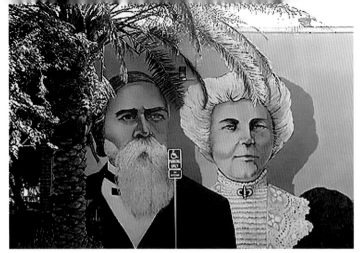

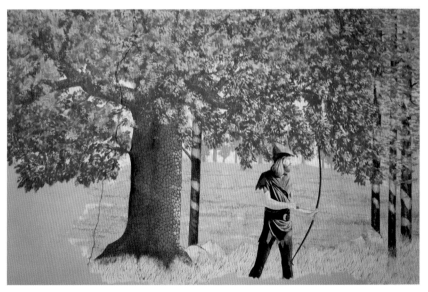

4. Windows *(top left)*

Collier Hardware, Broadway and First Streets, Scott Teeple, 1984

Scott Teeple shows how the building appeared in the 1940s and 1950s, before the windows of the hardware store were bricked in.

5. Annie and John Bidwell *(top right)*

Second Street near Broadway, Scott Teeple, 1982

In 1848 General John Bidwell discovered gold on the Feather River. He and his wife, Annie, built a mansion that became the center of social and political life in the upper Sacramento Valley. Bidwell encouraged early development in Chico by donating land to anyone willing to erect a house, church, school, or other public structure. One such building was Chico Normal School, constructed in 1887, which evolved into California State University, Chico.

6. Sherwood Forest *(bottom)*

Fourth and Main Streets, Scott Teeple, 1997

Owners of a toy store commissioned the mural to commemorate the 1938 Warner Brothers movie *Robin Hood*, starring Errol Flynn and filmed in Chico's Bidwell Park.

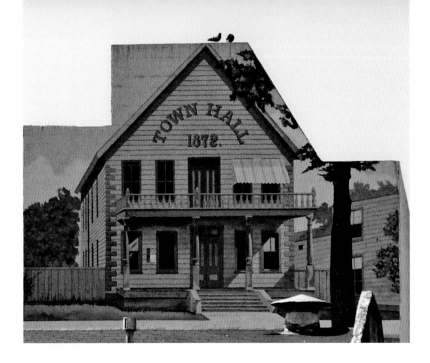

7. Town Hall 1872 *(top)*

319 Main Street, Scott Teeple, 2005

The mural is on a building that occupies the site of the old town hall. The image is based on a hand-colored photograph taken not long after the town hall was completed. For the best view, stand on nearby Fourth Street between Main Street and Wall Street and look north above the rooflines.

8. Trolley *(bottom)*

Chico City Plaza, Fifth and Main Streets, William Everone, 2007

Working from a vintage photograph, Everone duplicated the sepia tones by using a crystal soil and varnish medium. The soil, sifted to a fine crystalline dust, came from the site where the photograph was taken. He applied the varnish mixture in successive layers, alternating with clear varnish, to give the image a striking depth and radiance.

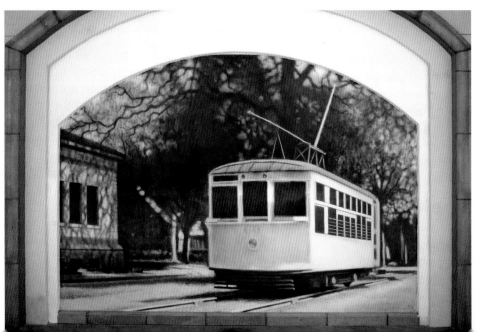

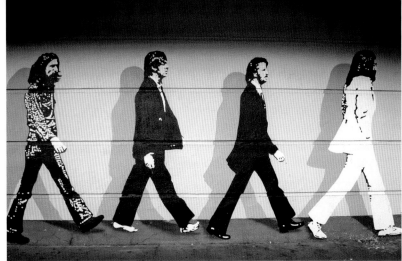

9. Space Walker *(top left)*

Fourth Street near Broadway, Craig Rasmussen and Scott Teeple, 1978

This mural was commissioned by the Downtown Chico Business Association to generate interest in Chico's historic downtown area.

10. Abbey Road *(top right)*

Main Street between First and Second, Gregg Payne, 1996

The image of the striding life-size Beatles is adapted from the 1969 album of the same name. They have been artistically transformed from crossing Abbey Road to strolling along a street in Chico. (The music store that sponsored the mural has since moved.)

11. White Birches *(bottom)*

Great Western Bank, Second and Salem Streets,
Scott Teeple and Craig Rasmussen, 1979

The mural was commissioned to complement the bank's new landscaping and add visual interest to the parking lot. The real birch trees have grown to match the height of the trees in the mural.

12. Sierra Nevada Brewery

1075 E. Twentieth Street, Eric Grohe, 1999

The trompe l'oeil murals suggesting a bas-relief depict the step-by-step brewing process, providing a visual reference for tour guides and visitors. The murals wrap around the entire room, covering approximately 1,500 square feet.

OTHER THINGS TO DO

· Bidwell Park: At 3,700 acres, this city park is the third largest in the United States and well worth a visit.

· Chico Museum: Located in a restored Carnegie Library building, this museum explores Chico's colorful past.

· Sierra Nevada Brewery: While visiting the murals at this site, you can take a guided or self-guided tour.

· Bidwell Mansion: A California historical landmark, this magnificent home of General and Annie Bidwell is a delight to tour. Visit the gift shop, museum, and theater.

· Chico State University: Explore the beautiful campus of Chico State. Check the university website for special activities and events.

· Downtown Galleries: Chico is an art town. Visit the numerous galleries and make sure to seek out the art glass galleries.

SUSANVILLE

Lassen County Chamber of Commerce
601 Richmond Road, Susanville, CA 96130
(916) 257-4323
www.visitlassen.com

As with many California towns, the lure of gold attracted the first settlers to the Susanville area. Issac Roop established a trading post and named the town after his daughter. In 1856 Roop and fellow pioneer Peter Lassen led a group of disgruntled settlers to protest the taxation of the sparsely populated area by county officials. The settlers revolted and opted to secede from the vast Utah Territory and form the Republic of Nataqua. Their daring feat was largely ignored, as the so-called republic consisted of only a few hundred widely dispersed residents. When the Territory of Nevada was established in 1861, Roop was made governor. This almost comical series of events had one more twist. Surveys made in 1864 determined that Susanville was actually part of the state of California.

The history of Susanville is fascinating, and the Lassen County Arts Council has developed an informative and enjoyable group of murals located in Susanville.

The Susanville Murals

1: Centennial Mural
2: Mr. Eastman
3: Dad Popcorn
4: Logging with Big Wheels
5: Isaac Roop and Daughter Susan
6: History of Lassen
7: Our Ancestors, Our Future
8: Creating Her History: A Tribute to the Women of Lassen County
9: Cattle Ranching in Lassen County
10: Old Main Street Susanville

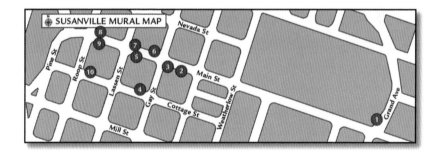

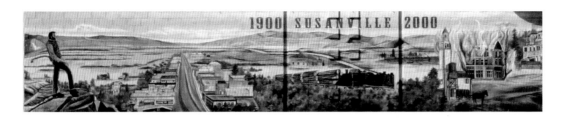

1. Centennial Mural

146' x 18', 50 Grand Avenue,
Janet Fraser Dickman, 2002

The mural, commissioned by the Susanville City Council, depicts important historical scenes from 1900 to 2000, including the fire at the old Emerson Hotel that destroyed an entire block of downtown. The work is located at the site where pioneers rested after crossing the desert on the Nobles Emigrant Trail.

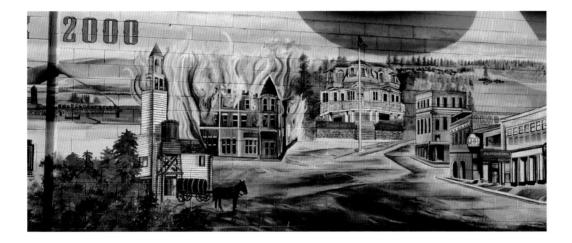

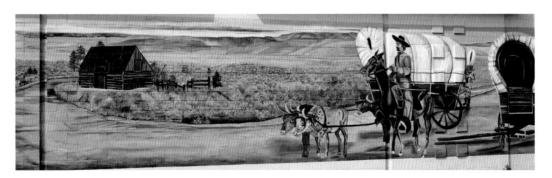

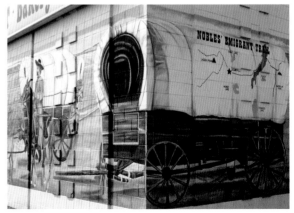

2. Mr. Eastman *(top)*

26' x 14', 802 Main Street,
Art Mortimer, 1993

The photographer depicted chronicled events in early Susanville. In keeping with the photographs of the time, Art Mortimer executed the mural in black and white.

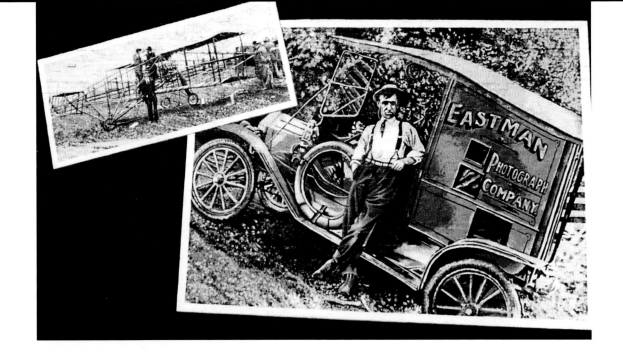

3. Dad Popcorn *(bottom)*

38' x 12', 800 Main Street, Ben Barker, 1993

William Vellenworth sold popcorn from his wagon between 1918 and 1931. Featured in the painting are the local Weir kids. One girl, about thirteen years old in the painting, came to watch the mural being painted. She was eighty-six.

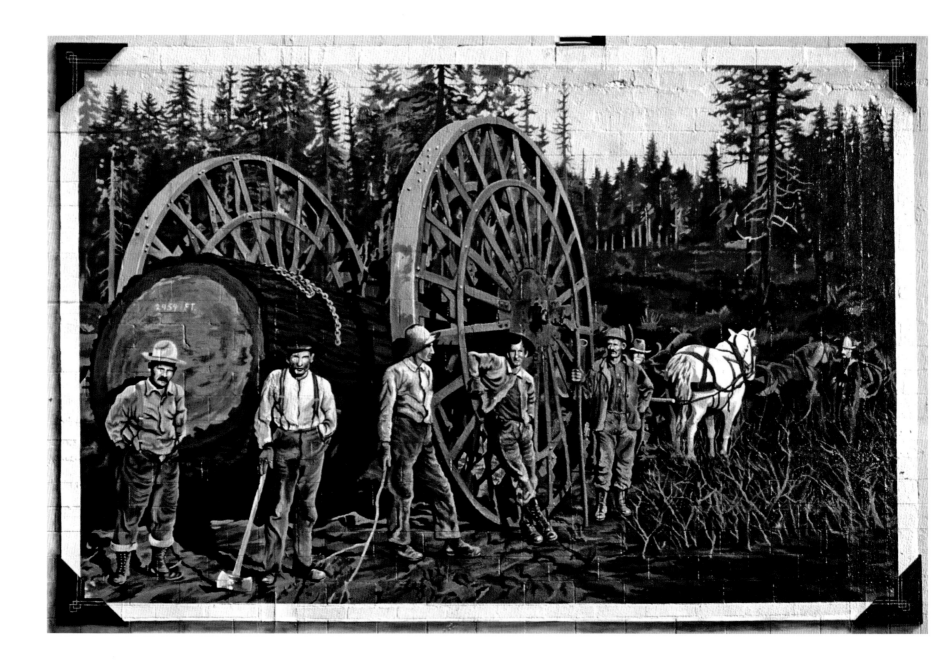

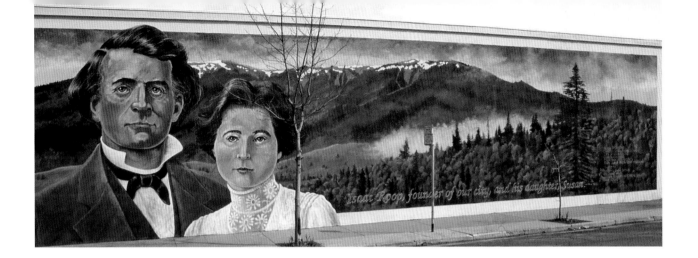

4. Logging with Big Wheels *(previous page)*

23' x 17', Cottage Street between Lassen and Gay Streets,
Ben Barker, coordinator, 2000

This mural salutes the history of the logging industry in Lassen County.

5. Isaac Roop and Daughter Susan *(top)*

70' x 18', Main and Lassen Streets, Ben Barker with
Leanna Lord Barker, 1989

Susanville pioneer Isaac Roop is shown larger than life. His daughter Susan,
namesake of Susanville, is to his right.

6. History of Lassen *(bottom)*

109' x 12', 715 Main Street, Ben Barker with Kathleen Colvin,
Mary Morphis, and Eileen Stevens, 1983

The early history of Lassen County is chronicled from the Native American
inhabitants to the arrival of the European settlers who would eventually
establish ranches and farms in the area.

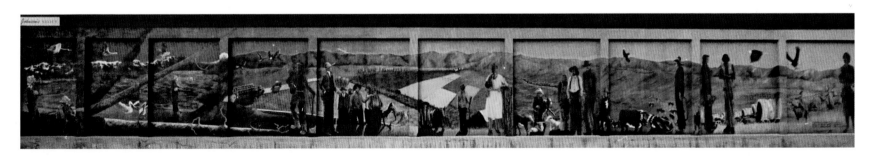

7. Our Ancestors, Our Future *(top)*

42' x 18', Main and Lassen Streets,
Jean LaMarr with Jack Malotte, 1999

This mural depicts the Native American heritage of this part of the state and the Indians' unique contribution to the area. It features portraits of historical Native American figures, including Chief Winnemucca.

8. Creating Her History: A Tribute to the Women of Lassen County *(bottom)*

50' x 15', Main and Roop Streets, Judith Lowry, 1993

Judith Lowry, who is of Mountain Maidu, Pit River, and Paiute descent, chose to recognize local women, including her grandmothers and great-grandmothers, and pioneer women.

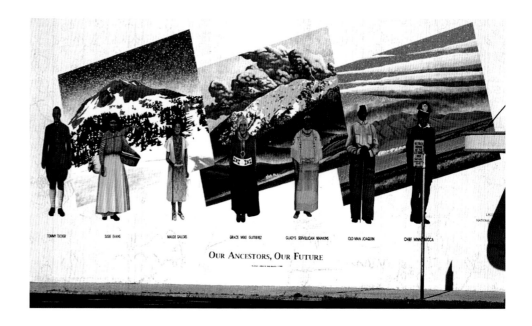

OUR ANCESTORS, OUR FUTURE

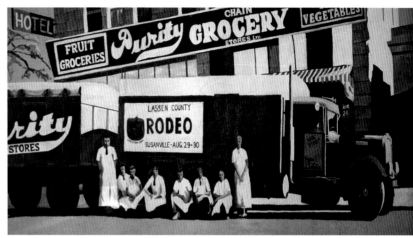

9. Cattle Ranching in Lassen County *(left)*

64' x 12', Roop and Main Streets, Art Mortimer, 1992

Muralist Art Mortimer toured Lassen County with a local rancher and then created the mural from photographs of people both past and present.

10. Old Main Street Susanville *(right)*

33' x 15', Roop and Cottage Streets, Sterling Hoffman and Lassen High School students, 1993

The mural captures the corner of Main and Gay Streets circa 1936 in a stylized and striking monochromatic fashion.

OTHER THINGS TO DO

· Roop's Fort and William H. Pratt Museum: This historic building dates from 1854.

· Lassen Historical Museum: Next door to the fort, this museum features old-time lumbering equipment and local artifacts.

· Historic Railroad Depot: This restored depot includes a visitor center and is located at the start of the Bizz Johnson National Recreational Trail that follows the Susan River.

· Lassen County Arts Council Gallery: This gallery on Cottage Street features local artists and a book on Lassen's murals.

3 EASTERN SIERRA MURAL ROUTE

Bishop

Eastern Sierra
Mural Route
Bishop •

San
Francisco

Los
Angeles

BISHOP

Bishop Area Chamber of Commerce and Visitors Bureau
690 N. Main Street, Bishop, CA 93514
(760) 873-8405 · (888) 395-3952
www.bishopvisitor.com

Bishop is in the heart of the Owens Valley, flanked by the peaks of the eastern Sierra Nevada. The Owens Valley has been inhabited for more than three thousand years, and evidence of early human presence can be found in petroglyphs just outside town. The area has a rich and sometimes violent history from the time of early residents, through the cattle and railroad days, to the notorious water wars in the early twentieth century. Today, Bishop is considered an outdoor enthusiast's paradise.

The Bishop Mural Society has done a remarkable job of documenting the area's history through an inclusive representation that does not varnish the truth. Bishop was the host of the 2005 California Mural Symposium.

The Bishop Murals

1: Lady Bug Art Gallery Façade
2: Turn of the Century
3: Bishop Bakery 1922
4-6: The Ernest Kinney Teamster Family Mural
7: The Kittie Lee Inn in 1924
8: Slim Princess
9: Dangerous Arrest in 1887
10: 4-H Quilt
11: Father Crowley
12: The Dirt on Bishop
13: The History of Medicine at the Local Pharmacy

14: Will Rogers in Bishop
15: The Local Pharmacy: George Deibert
16: The Local Pharmacy: Peering through the Window
17: The Local Pharmacy: Enjoying a Milkshake
18: The Local Pharmacy: Dr. Robert Denton
19: The Sunland Orchard, circa 1912
20: Drain
21: The History of Mining in Bishop

BISHOP MURAL MAP

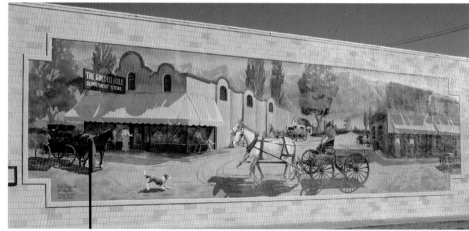

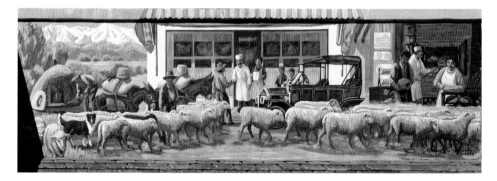

1. Lady Bug Art Gallery Façade *(top left)*

462 Rose Street, various local artists, 1996

The Bishop mural program had its humble beginnings at a gallery owned by Barbell Williams, who became a driving force behind the program and served as its president for many years. This simple mural consists of several illusionary windows on the walls.

2. Turn of the Century *(top right)*

Sierra Office Supply, Willow and Main Streets,
John Knowlton, Bob Unkrich, and Kathy Sexton, 1997

The mural shows the corner as it was a century ago, when Bishop was the center of a prosperous farming and ranching area. The limited range of colors gives the mural a vintage look. You can almost taste the dust in the air.

3. Bishop Bakery, 1922 *(bottom)*

Main and Line Streets, Janet Essley, 1998

Sheep have been raised in the Owens Valley since the 1860s and were often herded down Main Street. Two types of baking ovens are depicted at the far right and far left. The town is known for rustic sheepherder bread.

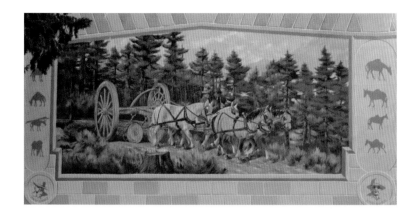

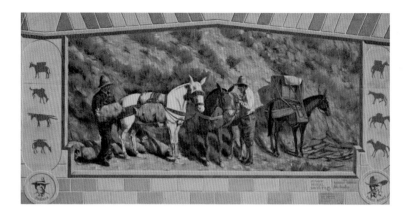

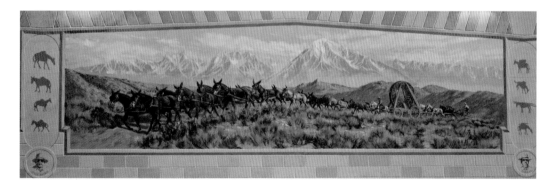

4–6: The Ernest Kinney Teamster Family Mural

Union Bank of California, 362 N. Main Street, Robert Thomas, John Knowlton, and Rich Perkins, 1999

4: *(top left)* This first image of a triptych on the bank's north wall shows local timber operations in the mid-1800s, when mule teams hauled the felled trees to the sawmill. The stone border around the individual panels is painted trompe l'oeil.

5: *(middle)* Mule teams were capable of carrying large loads under the eagle eye and firm hand of the mule skinner.

6: *(top right)* The early economy of the area depended on mule power. Here, pack mules are being loaded at the Champion Spark Plug Mine.

7. The Kittie Lee Inn in 1924 *(top)*

Whiskey Creek Restaurant, 524 N. Main Street, Robert Thomas, John Knowlton, and Rich Perkins, 2000

The mural is on the south side of the restaurant, which occupies the site of the original inn, which was considered to be the height of luxury. In its heyday, it was popular with Hollywood stars such as Will Rogers, Cary Grant, John Wayne, and Bing Crosby.

8. Slim Princess *(middle)*

Fendon's Furniture, 175 E. Pine Street, Robert Thomas, John Knowlton, and Rich Perkins, 2000

Laws, a community just outside Bishop, had a thriving railroad depot built in 1883, which served the Owens Valley until 1960, when the railroad made its last run.

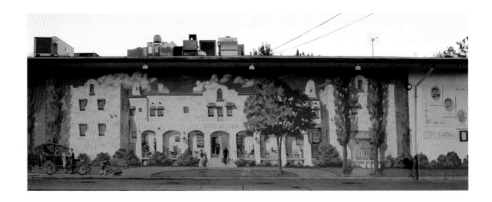

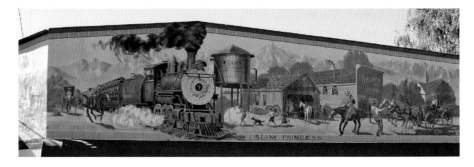

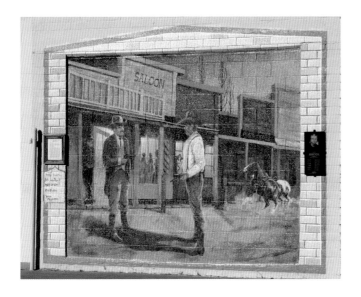

9. Dangerous Arrest in 1887 *(bottom)*

Bishop Police Department, 207 W. Line Street, Kathy Sexton, Rich Perkins, Jenna Morgenstein, John Knowlton, and Mary Gipson-Knowlton, 2001

The mural, on the east side of the police building, describes an event from the early years when Bishop was a wild town whose lawlessness rivaled that of the Texas frontier.

10. 4-H Quilt (top)

Douglas Robinson Building, Tri-County Fairgrounds, Janet Essley, 2001

The hundredth anniversary of the local 4-H club was the occasion for honoring the club's members and their activities.

11. Father Crowley (bottom)

Z's Flowers & Things, 197 N. Main Street, John Knowlton, 2002

Nicknamed the "Desert Padre," Crowley was a fascinating, multifaceted character who wrote a weekly column about local flora and fauna and promoted the area to the movie industry in the 1930s. Among his friends were many movie stars of the era, including Gary Cooper and Cary Grant. Father Crowley died in an auto accident in 1940 at age forty-eight. Crowley Lake is named after him.

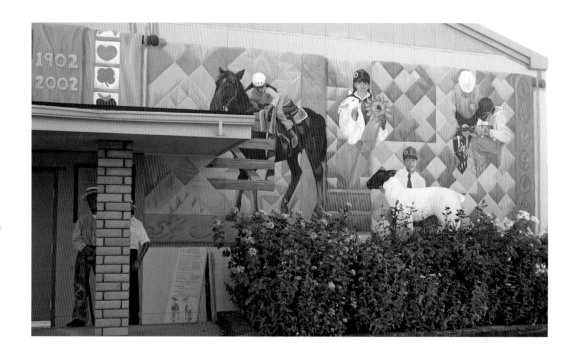

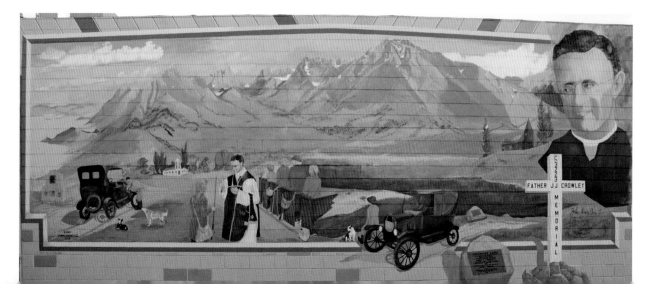

12. The Dirt on Bishop

Belle Vous, 230 W. Line Street,
John Pugh, 2002

In this masterful example of trompe l'oeil,
John Pugh views the history of land owner-
ship while revealing the layers of a core of
the earth. When the mural was created, the
building was occupied by a title company.

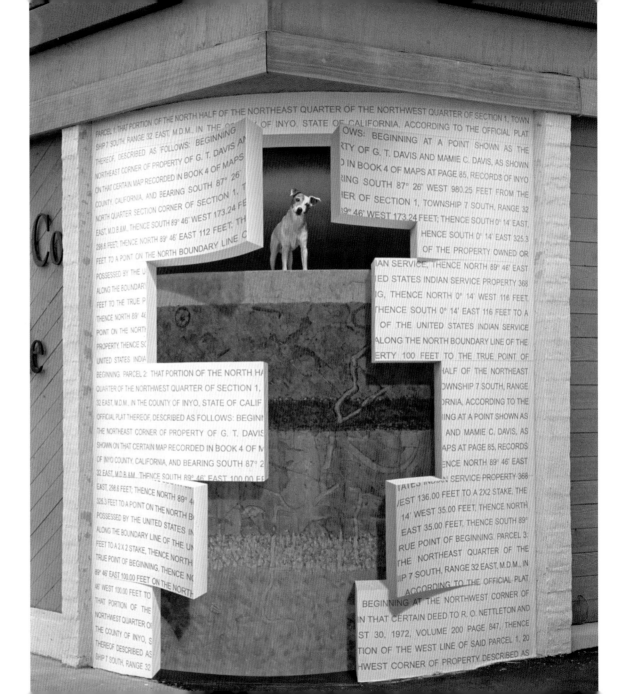

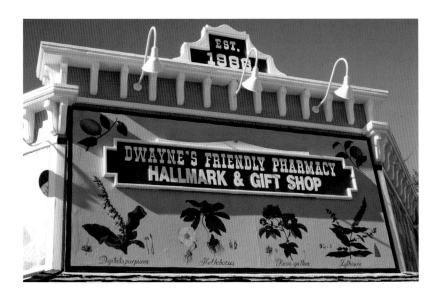

13. The History of Medicine at the Local Pharmacy *(top)*

Dwayne's Friendly Pharmacy, 644 W. Line Street, Phillip Slagter, 2003

The facade, with medicinal herbs and citrus fruits, is one of a series of murals on the pharmacy walls.

14. Will Rogers in Bishop *(bottom left)*

Dwayne's Friendly Pharmacy, 644 W. Line Street, Phillip Slagter, 2003

In the 1930s, film star Will Rogers bought local Native American children ice cream at the pharmacy soda fountain when he came to town. They had to eat outside because Indians were not allowed in the pharmacy. Rogers was part Indian himself.

15 and 16. The Local Pharmacy: George Deibert; Peering through the Window *(bottom right)*

Dwayne's Friendly Pharmacy, 644 W. Line Street, Phillip Slagter, 2003

A pair of murals re-create the advertisements found in old drugstores. The left one shows pharmacist George Deiber, longtime Bishop resident.

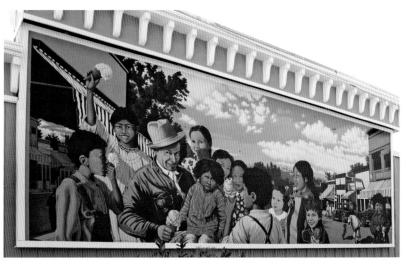

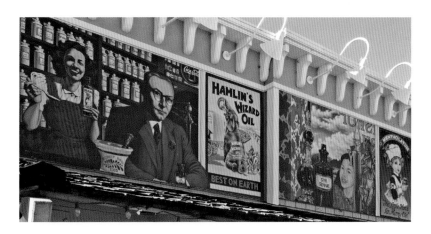

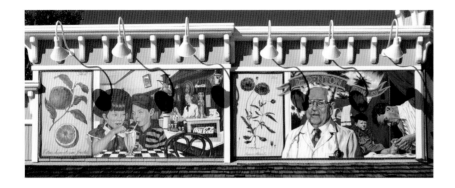

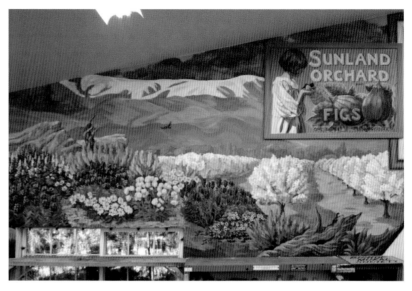

17 and 18. The Local Pharmacy: Enjoying a Milkshake; Dr. Robert Denton *(top left)*

Dwayne's Friendly Pharmacy, 644 W. Line Street, Phillip Slagter, 2003

The oranges on the left continue the theme of the mural on the facade of the pharmacy. Dr. Robert Denton was a well-known Bishop resident.

19. The Sunland Orchard, circa 1912 *(top right)*

Bishop Garden Nursery, 789 Home Street, Janet Essley, 2005

The fruit-packing label evokes a time when the Owens Valley was an orchard wonderland, before water was diverted to the cities of southern California.

20. Drain *(bottom)*

Line and Fowler Streets, John Pugh, 2005

A rusty old water pipe siphons the water from the Owens Valley, a reference to the early twentieth-century water wars, when the city of Los Angeles bought land in the Owens Valley and drained the valley nearly dry.

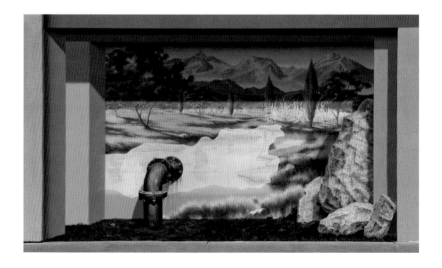

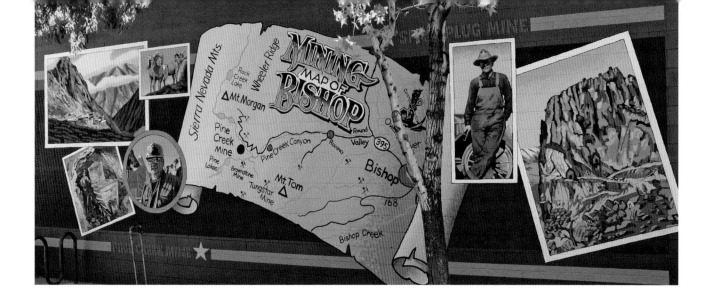

21. The History of Mining in Bishop

Academy and Main Streets, Art Mortimer, 2005

Art Mortimer served as master muralist for this mural-in-a-day carried out during the 2005 California Mural Symposium. Gold, silver, coal, and tungsten were all mined in and around Bishop.

OTHER THINGS TO DO

· Laws Railroad Museum: This railroad station has been completely restored and offers a glimpse of a frontier depot with many out-buildings and a gift store.

· Numerous Lakes and Streams: The area around Bishop is specta-cular with many spots to fish and hunt.

· Visit Nearby Mammoth: Mammoth is a world-class ski area with an attractive village.

TRAVELING EAST?

After you have completed the Bishop mural tour, if you are travel-ing east into Nevada and perhaps Utah, be sure to visit the murals towns of Tonopah and Ely on US 6, which begins just north of Bishop off US 395.

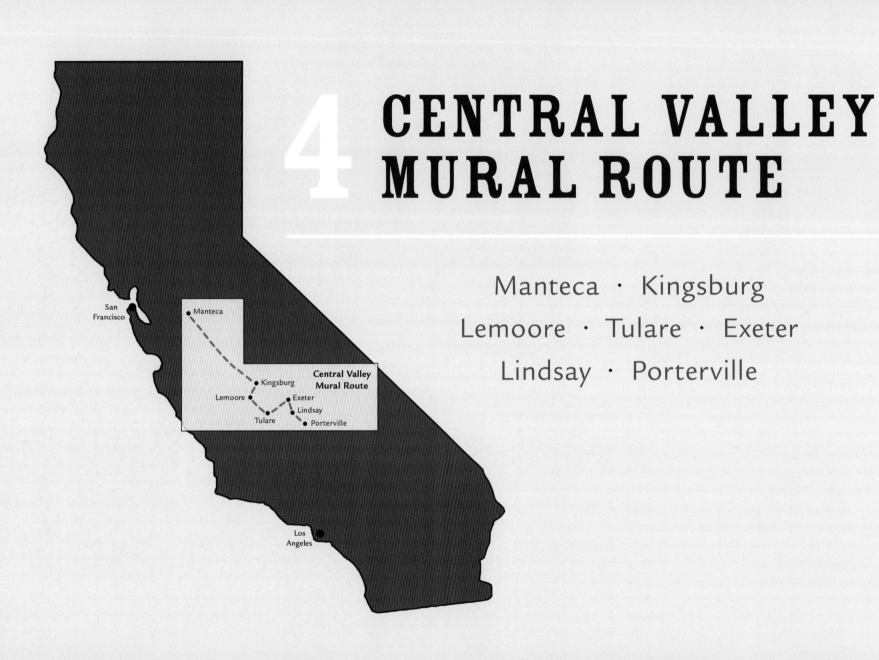

4 CENTRAL VALLEY MURAL ROUTE

Manteca · Kingsburg

Lemoore · Tulare · Exeter

Lindsay · Porterville

MANTECA

Manteca Convention and Visitors Bureau
PO Box 1058, Manteca, CA 95336
(209) 823-7229
www.visitmanteca.org

Manteca Mural Society
PO Box 1666, Manteca, CA 95336
(209) 823-7229
www.mantecamurals.org

Originally, Native Americans occupied the Manteca area, then known as the "sand plains." Settlers began arriving in the late 1800s, as the California Gold Rush subsided, and called their valley settlement Cowell Station, after Joshua Cowell, later dubbed the "father of Manteca." At first, a boxcar served as Cowell Station. Because another Cowell Station (after Joshua's brother Wright) was located south of Tracy, the town's name was changed to Monteca. The railroad misprinted the first tickets with the spelling of Manteca (Spanish for "lard"). The error displeased the townspeople but was never corrected.

There was little activity in Manteca that was not related to agriculture until World War II. Changes came slowly up through the 1970s, and today Manteca boasts diversified manufacturing and high-tech industries.

The Manteca Mural Society is a true success story. In the years since its inception in 2003, it has sponsored eight large-scale murals and has plans for more. In addition, it was the sponsor of the 2007 California Mural Society Symposium.

The Manteca Murals

1:	Crossroads	5:	Service Above Self
2:	Sierra's Crown	6:	Cow-munity Mural
3:	Pumpkin Harvest	7:	Summer Vision
4:	Golden Gateway to Manteca	8:	Free-for-All
		9:	Our Bountiful Valley

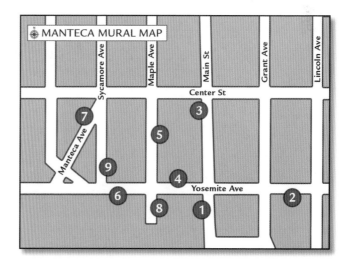

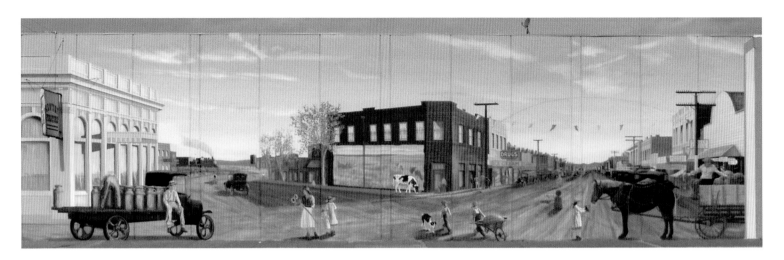

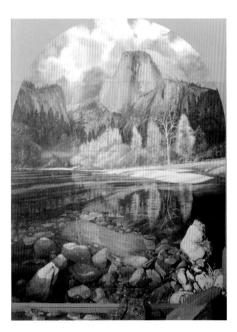

1. Crossroads *(top)*

Main Street and Yosemite Avenue, Dave Gordon, 2003

In 1918 the intersection of Main and Yosemite was the crossroads of the small farming community. On clear days, like the one when this photo was taken, the blue sky of the mural blends into the real sky.

2. Sierra's Crown *(bottom)*

226 E. Yosemite Avenue, Dan Petersen, 2005

The centerpiece is Half Dome in Yosemite National Park, east of Manteca. The rocks in front of the mural mimic the painted rocks in the foreground, providing a transition between reality and illusion.

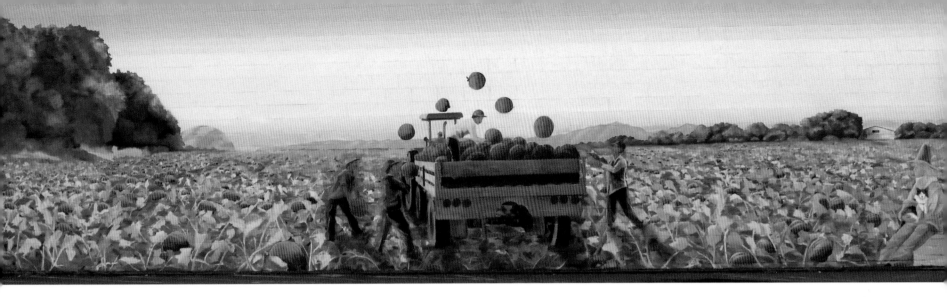

3. Pumpkin Harvest *(top)*

145 N. Main Street, Dave Gordon with Pete Evaristo and the
Manteca community, 2004

Manteca is one of the largest pumpkin-growing areas in the country.

4. Golden Gateway to Manteca *(bottom)*

213 W. Yosemite Avenue, Ron Pecchenino, 2005

The mural reflects the proximity of San Francisco to Manteca. As the area
has grown, Manteca has in some ways become a suburb of the greater
Bay Area and its ties to San Francisco have become more evident.

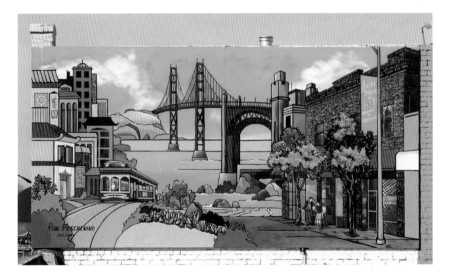

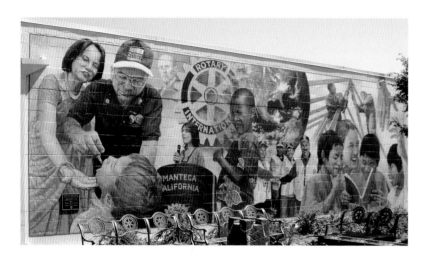

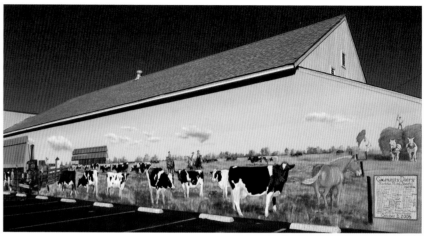

5. Service Above Self *(top left)*
158 N. Maple Avenue, Don Gray, 2005

Rotary International's hundredth anniversary prompted creation of the mural.

6. Cow-munity Mural *(top right)*
230 W. Yosemite Avenue, Dave Gordon with Pete Evaristo and the Manteca community, 2005

Local volunteers created the mural over a weekend, and there was plenty of reminiscing about dairy life.

7. Summer Vision *(bottom)*
Library Park, 320 W. Center Street, Terri Pasquini with the children of Manteca, 2006

This mural provides a whimsical look at Manteca through the eyes of children.

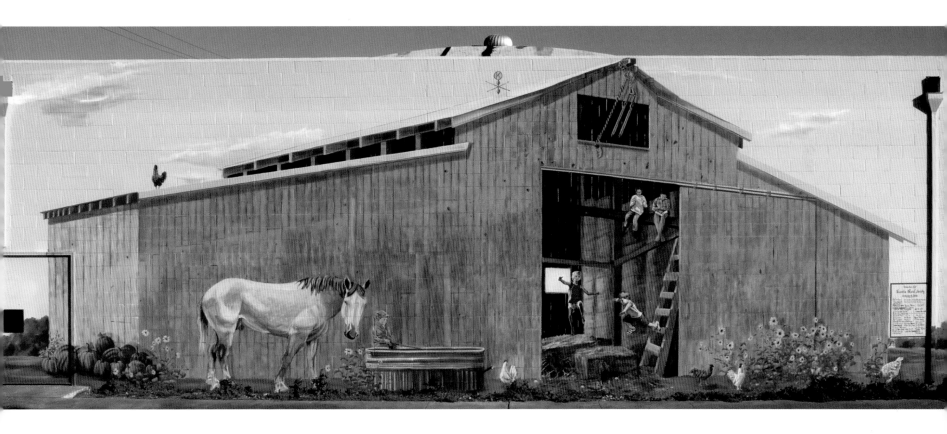

8. Free-for-All
ABC Transmission, Maple Avenue south of Yosemite Avenue,
D. S. Gordon, 2006

A weekend project painted by volunteers, the mural was sponsored by the
local Kiwanis Club and includes some of its special projects: fishing derbies,
reading programs, and the local pumpkin fair.

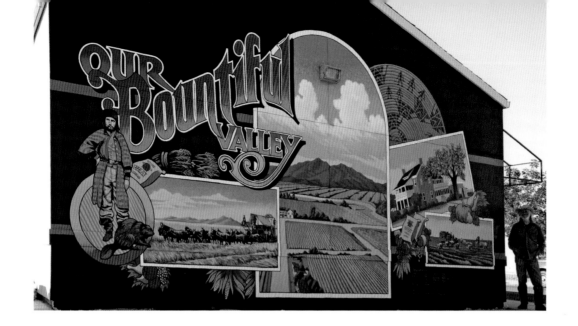

9. Our Bountiful Valley

Sycamore Avenue north of Yosemite Avenue, Art Mortimer, 2007

The mural recognizes the wealth of California's Central Valley and those who have contributed to it.

OTHER THINGS TO DO

· Manteca Historical Society: Displays illuminate the history of Manteca and the Central Valley.

· Big League Dreams: The park has replicas of six famous ballparks, including Fenway Park, Wrigley Field, and Yankee Stadium, along with batting cages.

· Caswell Park: The 260-acre park has a picnic area and campsites and opportunities for wildlife watching, hiking, and swimming.

· Tidewater Bike Path: The 3.4-mile path, also used by joggers, runs through the heart of Manteca.

· Manteca Historical Walking Trail: The 1.5-mile tour covers many historical sites. Pick up a brochure with a map at the Manteca Convention and Visitors Bureau.

KINGSBURG

Kingsburg Chamber of Commerce
1475 Draper Street, Kingsburg, CA 93631
(559) 897-1111
www.kingsburgchamberofcommerce.com

In the early 1870s, reports of a warm climate, farming opportunities, and free government land prompted two Swedes to settle in a Central Pacific Railroad town called Kings River Switch. Shortly thereafter, the present town site was drawn up and the name was changed to Kingsbury. The name later became Kingsburgh, and in 1894 Kingsburg. In the 1920s approximately 94 percent of the population within a three-mile radius of Kingsburg was Swedish American, giving the community the nickname of Little Sweden, which it retains to this day.

The town's mural project salutes both this Swedish heritage and the town's diversity.

The Kingsburg Murals

1: Friends of the Kingsburg Library
2: The Making of Kingsburg
3: Mid-Summer Day

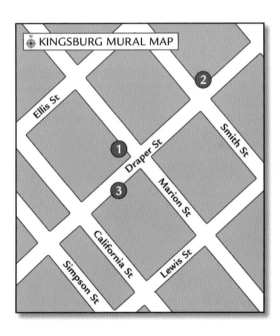

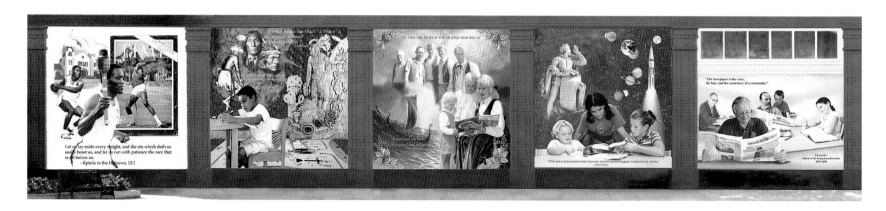

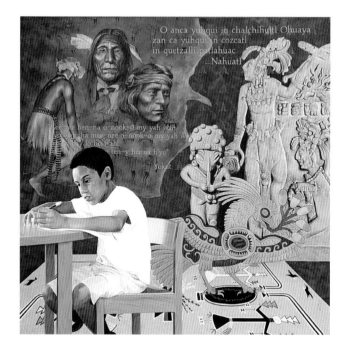

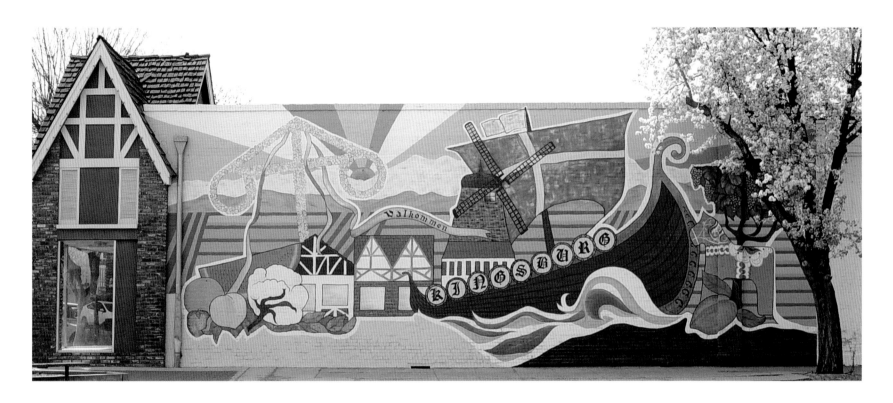

1. Friends of the Kingsburg Library *(previous page)*

62'6" x 12'6", Draper and Marion Streets, Maxine Olson and
Colleen Mitchell-Veyna, 2003

The five panels, totaling just over sixty-two feet in width, include historical,
cultural, and literary content. Olympic gold medalist Rafer Johnson,
who attended a Kingsburg high school, is the subject of the first panel.
Subsequent panels show a Hispanic student researching his ancestors; a
Swedish family; young people reading in the library; and the importance
of the local newspaper to the community.

2. The Making of Kingsburg *(above)*

49' x 20', Smith and Draper Streets, Phyllis Johnson with Suzette Ekberg,
Ray Luna, Annie Lopez, John Bowlin, and John Hurtado, 1978

Phyllis Johnson, a teacher at the local high school, worked with her
advanced art students to create this mural about the town's Swedish
heritage.

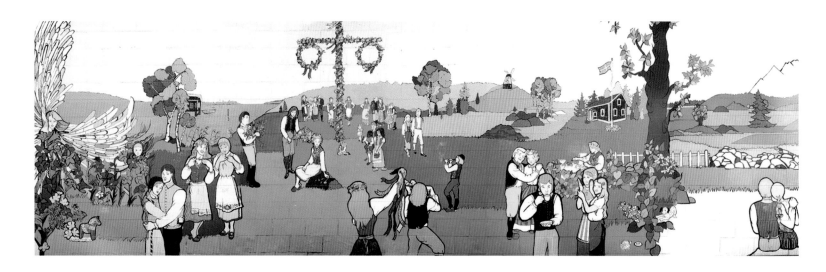

3. Mid-Summer Day

30' x 11', Gino's Italian Restaurant, alley south of Draper Street,
Kitty Kirkland, 1998

Swedish-Finn artist Kitty Kirkland depicts a Swedish Mid-Summer Day
celebration in what appears to be a Swedish landscape.

OTHER THINGS TO DO

· Kingsburg Historical Museum: Displays focus on the history
 of Kingsburg.

· Kingsburg Art Center: An eclectic art center and gallery.

· Annual Events: Time your visit to coincide with annual events,
 including the Kingsburg Swedish Festival in May, the Summer
 Band Concerts Under the Stars, and the Santa Lucia Festival and
 Christmas Parade. See the chamber website for more information.

LEMOORE

Lemoore Chamber of Commerce
300 E. Street, Lemoore, CA 93245
(559) 924-6401
www.lemoorechamberofcommerce.com

Tulare Lake was the largest freshwater lake in the western United States until the late 1800s, when a series of reclamation projects drained the lake, resulting in an expanse of marshlands. Water was still plentiful, however, and supported a few productive farms in the area. Dr. Lee Moore used his organizational skills to draw the residents together. He secured a post office and then a railroad station. Streets and homes were constructed, and businesses established, but the fledgling town still did not have a name. It was common for towns to be named after prominent citizens, so this one became Lemoore, a contraction of Dr. Moore's name. In 1900 Lemoore was incorporated.

The Lemoore Murals

1: Can't Bust 'Em Overalls Billboard
2: Tachi Yokut Sunset
3: The Present Looks at the Past
4: Vintage Pharmacy
5: The First Ten Decades
6: Arrow's Stationers Mural
7: Making Cheese in Lemoore

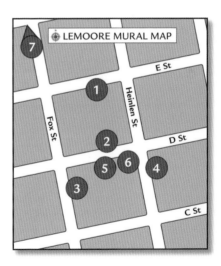

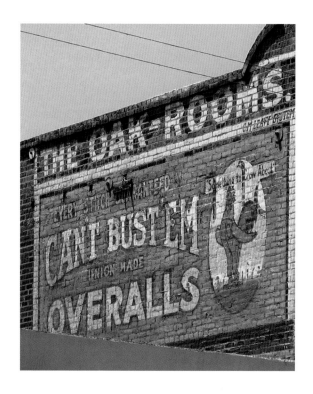

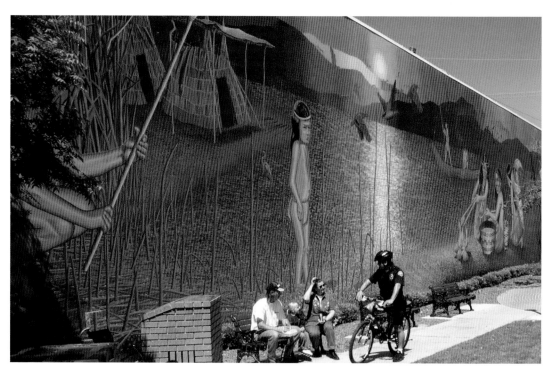

1. Can't Bust 'Em Overalls Billboard *(left)*

325 W. E Street, artist unknown, circa 1900

This vintage billboard mural is at least a century old and has survived the product it promoted.

2. Tachi Yokut Sunset *(right)*

D Street Plaza, 334 W. D Street, Colleen Goodwin Chronister, 2002

The native Yokuts are shown engaged in their daily activities at the edge of historic Tulare Lake. The mural faces west and mirrors the reds and oranges of the actual sunset, but may suffer from the fading effects of the intense UV light of a western exposure.

3. The Present Looks at the Past (top)

D Street Plaza, 320 W. D Street, Colleen Goodwin Chronister, 1999

Life-size contemporary figures in the mural point out the features of downtown Lemoore at the turn of the century. The eagle in the center was the U.S. Treasury's model for the silver dollar.

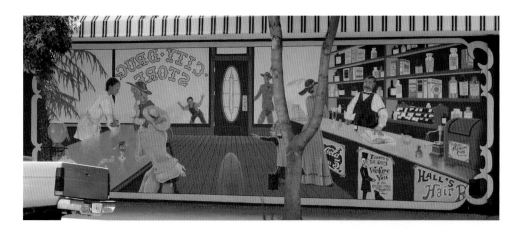

4. Vintage Pharmacy (middle)

Odd Fellows Building, 246 Heinlen Street,
Colleen Goodwin Chronister, 1999

Painted on the wall of a contemporary pharmacy, the mural offers a whimsical look inside an old-time pharmacy, complete with a soda fountain.

5. The First Ten Decades (bottom)

Wells Fargo Bank, 301 W. D Street, Colleen Goodwin Chronister with community volunteers, 2000

Lemoore marked its centennial with a mural-in-a-day painted by more than one hundred residents.

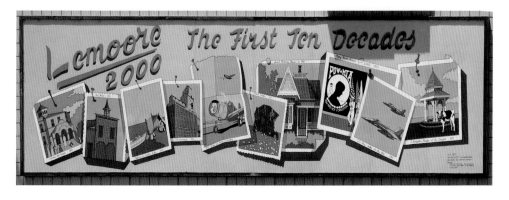

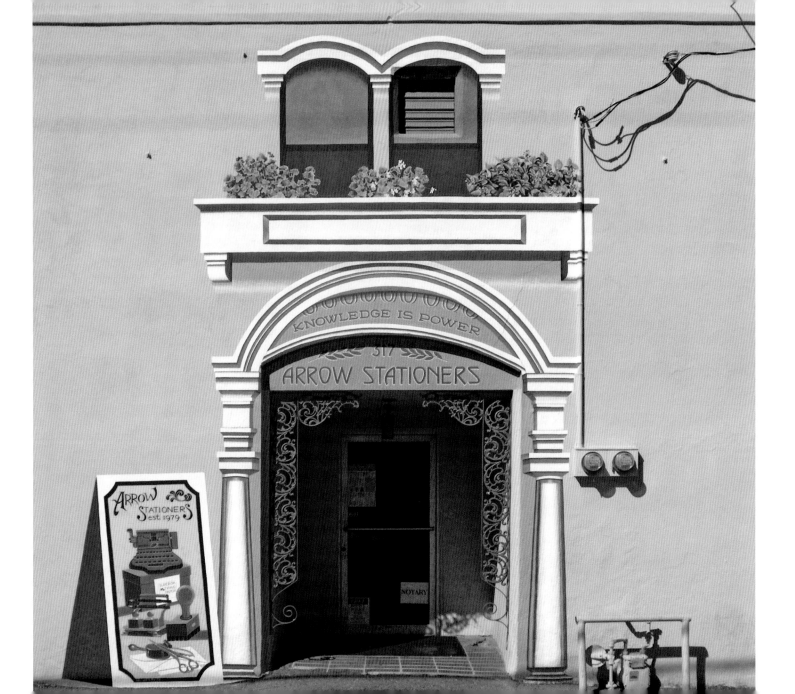

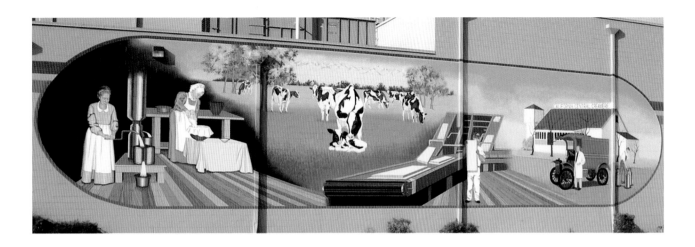

6. Arrow's Stationers Mural (*previous page*)

317 W. D Street, Colleen Goodwin Chronister, 2003

The trompe l'oeil mural creates a welcoming, nostalgic entrance for a contemporary stationery store.

7. Making Cheese in Lemoore, CA (*above*)

Fox and F Streets, Colleen Goodwin Chronister, 2007

Lemoore is in the heart of some of the most productive dairyland in the state. The mural shows the historic progression of cheese making from the early days of hand churning to modern practices.

OTHER THINGS TO DO

· Sarah A. Mooney Memorial Museum: Visit this Victorian home, which is fully furnished with period pieces.

· Historical Downtown Lemoore Walking Tour: Sponsored by the Lemoore Chamber of Commerce, this tour includes many historical buildings, and the murals as well. Check with the chamber for a map.

TULARE

Tulare Chamber of Commerce
220 E. Tulare Avenue, Tulare, CA 93274
(559) 686-1547
www.tularechamber.org

Tulare, which derives its name from the Spanish for "cattail," was founded in 1872 by the Southern Pacific Railroad to serve as its San Joaquin Valley headquarters. The town's early years were difficult. In its first fourteen years, Tulare burned down and was rebuilt three times. It was incorporated in 1888.

Residents faced hardship again in 1891 when Southern Pacific relocated its valley headquarters to Bakersfield. Residents turned to agriculture for their livelihood but faced the challenge of finding enough water. They founded the Tulare Irrigation District and issued $500,000 in bonds to construct an extensive canal system to carry water from the Sierra Nevada. The town paid the bonds off early and in 1903 celebrated with a bond-burning celebration. Agriculture remains the lifeblood of the local economy.

The Tulare Murals

1: Tulare Water Tower
2: Tulare Union High School Mascot
3: Rankin Field
4: The Bears
5: Yokut of Central California
6: The Elopement
7: Lindsay Lemons Building
8: Man versus Pigeons
9: The Donut Girls
10: Adohr Milk Farms
11: The Train
12: E. J. Ryan Druggist
13: Linders
14: Yosemite
15: The Garage
16: Agricultural Showcase
17: Blackstone Market

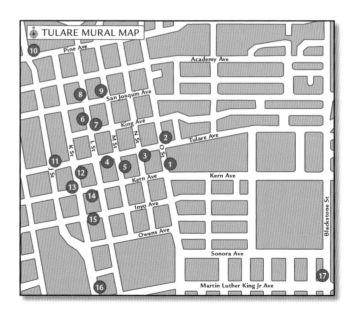

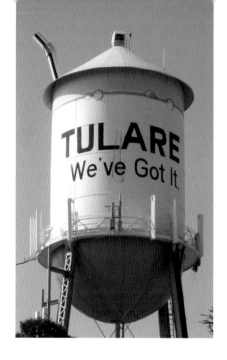

1. Tulare Water Tower *(top left)*
120' tall, Kern Avenue and O Street,
Colleen Goodwin Chronister, 2006

The historic water tower, nearly a century old and still used to store water, was painted to resemble a glass of milk, including a fifteen-foot red-and-white drinking straw. "We've Got It" is the city's slogan.

2. Tulare Union High School Mascot *(top right)*
16' x 14', Tulare Avenue and O Street,
George White, 1978

The mural was designed by John Delfino, a 1969 Tulare Union High School graduate and local Tulare artist. It was painted by George White and was a gift to the school from the class of 1978.

3. Rankin Field *(bottom)*
50' x 10', 509 E. Tulare Avenue,
Colleen Mitchell-Veyna, 1998

Rankin Aeronautical Academy, established in 1941, trained more than ten thousand cadets during World War II. On the left is Richard Ira Bong, World War II ace, in his P-38 fighter. Tex Rankin, stunt pilot and president of the academy, is at right.

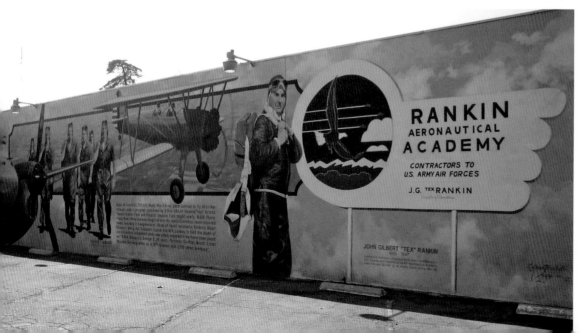

73

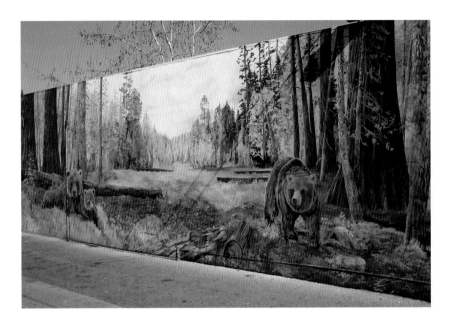

4. The Bears *(top)*

30' x 14', 333 E. Tulare Avenue, Nadi Spencer, 2000

A family of grizzly bears occupies a meadow with the Sierra Nevada in the background. Grizzly bears once roamed the region. The last one was killed in Porterville in the 1920s.

5. Yokut of Central California *(bottom)*

40' x 12', 125 S. M Street, Colleen Mitchell-Veyna, 2005

The Tulare Cultural Arts Foundation wanted to recognize local Native Americans, the Yokuts, and their way of life through two murals on the Civic Affairs Building. The one shown here faces east toward Zumwalt Park.

6. The Elopement *(next page)*

10' x 6', 237 N. L Street, Colleen Goodwin Chronister, 1996

The groom wears 1917 U.S. Army attire. The bride has snagged her skirt on the window frame. To play off the illusion, a real ladder is propped up against the house beneath the mural.

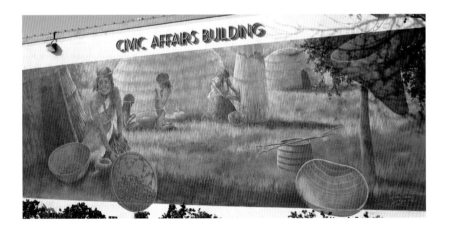

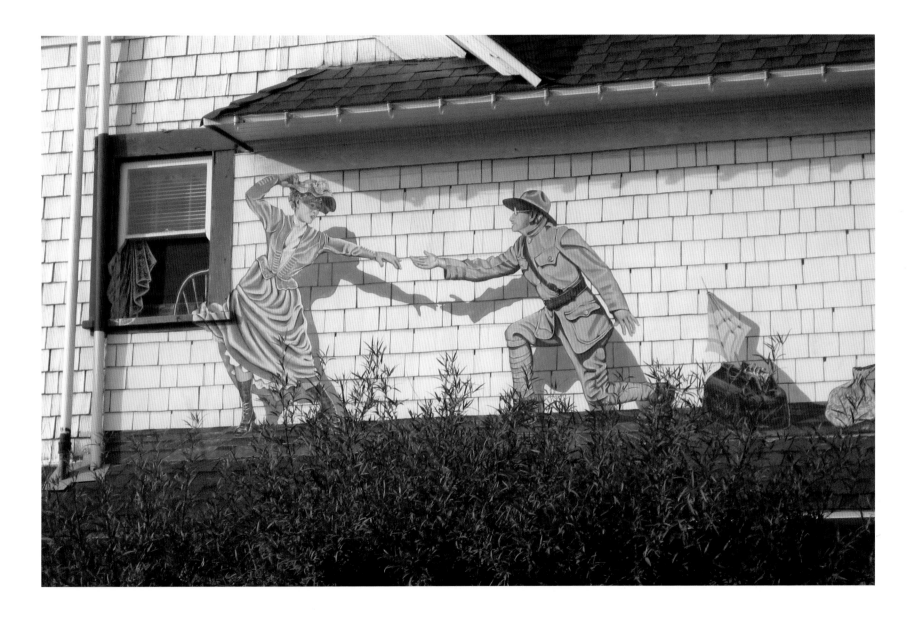

7. Lindsay Lemons Building *(top)*

240' x 6', King Avenue and L Street, Michael Kohler, 2005

The frieze is a whimsical evocation of a small downtown in the 1920s.

8. Man versus Pigeons *(bottom)*

7' x 8', 244 E. San Joaquin Avenue, Mike Kohler, 2007

A lifelike pigeon trapper is poised to strike.

9. The Donut Girls *(next page)*

9' x 8', 300 E. San Joaquin Avenue, Patrick Barszcz, 1999

This mural is a tribute to the Salvation Army donut girls, who kept the men's morale up during the war.

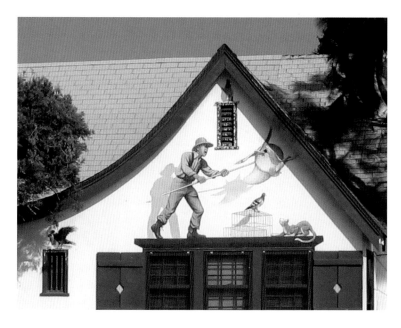

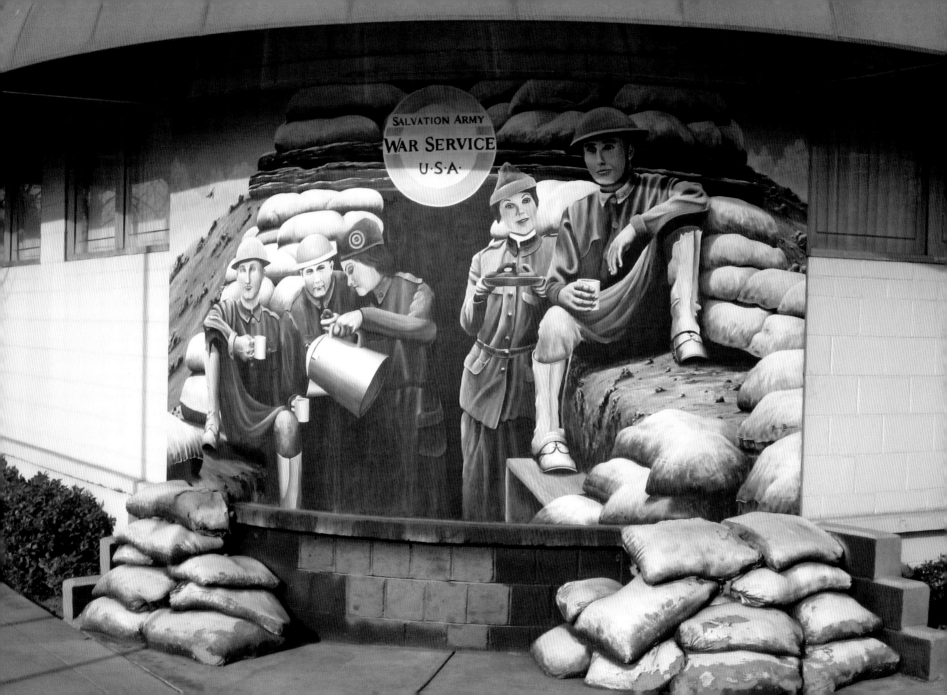

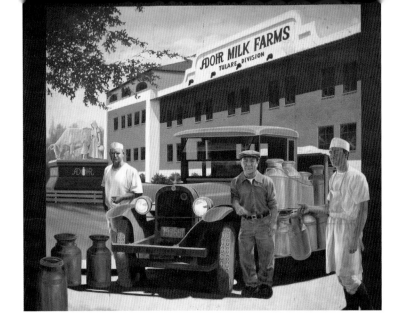

10. Adohr Milk Farms *(top)*

8' x 8', 605 N. J Street, Colleen Mitchell-Veyna, 2004

Tulare Cultured Specialties Corporation was originally a creamery named Adohr Milk Farms, founded in 1916 by Merritt and Rhoda Adamson (Rhoda spelled backward is Adohr). Six years before the mural was created, the Adohr cow, a historic sculpture seen in the mural at far left, was restored by Jim Hitchcock and James Hitchcock.

11. The Train *(bottom)*

150' x 8', Tulare Avenue and J Street, Michael Kohler, 1999

This mural, which wraps around two sides of the building, depicts a typical train passing through Tulare in the late 1800s.

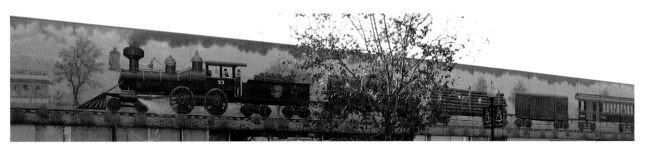

12. E. J. Ryan Druggist *(top)*

15' x 8', 140 S. K Street, Michael Kohler, 1996

Ryan, the building's first owner, operated the drugstore downstairs in the 1920s. The subject matter of the trompe l'oeil painting suits the historic structure.

13. Linders *(bottom)*

30' x 10', 160 S. K Street, Colleen Mitchell-Veyna, 1998

The two partners, Linder and Harlow, are shown in front of the Carriage and Wagon Repository, their first joint venture. Linder became a state senator, and his descendants still live in Tulare. The scene is a composite of Linder and Harlow's building and the park across the street.

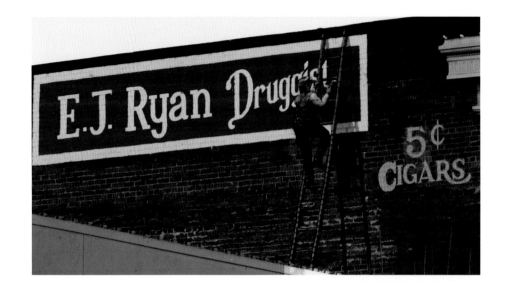

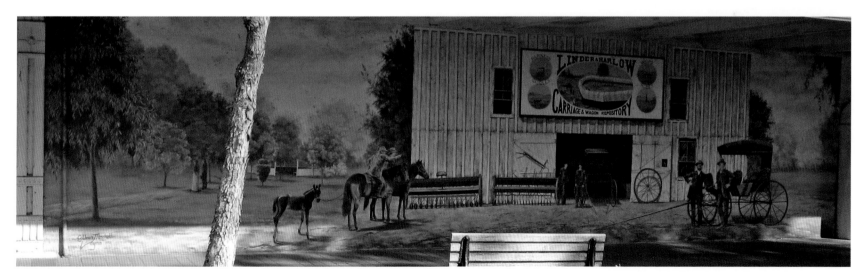

79

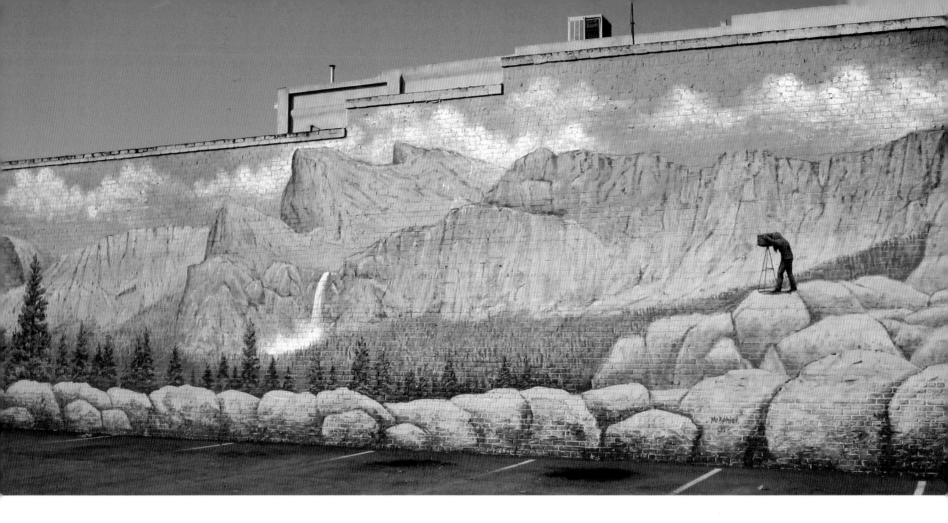

14. Yosemite

125' x 15', 227 E. Kern Avenue, Michael Kohler, 1999

At 120 feet long, this mural is the town's largest. It was painted entirely
with a sponge. The photographer, on the right, is Ansel Adams.

15. The Garage *(top)*

80' x 20', 251 S. L Street, Michael Kohler, 2001

The mural is a composite of several photographs from the archives of the Tulare Historical Museum.

16. Agricultural Showcase *(middle left, middle right, and bottom)*

215 Martin Luther King Jr. Avenue, Michael Kohler, 2001

This trio of murals, a joint effort of the Tulare County Fair and the Tulare Cultural Arts Foundation, highlight the county fair and the natural environment.

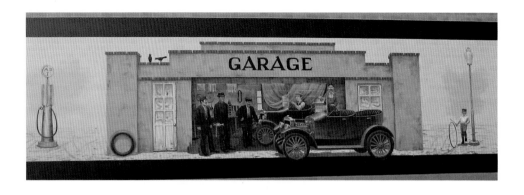

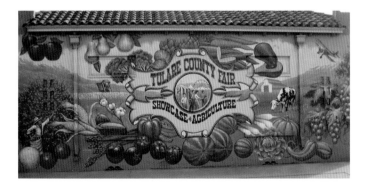

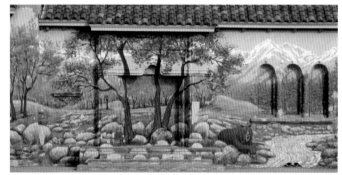

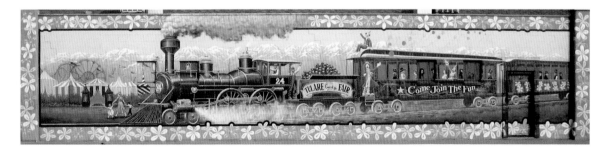

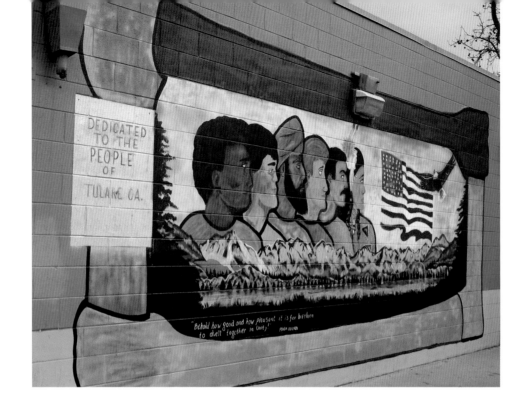

17. Blackstone Market

17' x 12', 520 S. Blackstone Street, Tony Reyna, 1986

This early mural includes a reference to Psalms 133:1: "Behold how good and how pleasant for brothers to dwell together in unity!"

OTHER THINGS TO DO

· Heritage Complex: The complex includes an Antique Farm Equipment Museum and the AgVentures learning center.

· Tulare Historical Museum: This museum, showcasing the history and progress of Tulare, has been noted as one of the best small-town museums in California.

· Sequoia National Park: The entrance to Sequoia National Park is about forty-five minutes from Tulare. The park is home to one of the world's biggest trees, General Sherman.

EXETER

Exeter Chamber of Commerce
101 W. Pine Street, Exeter, CA 93221
(559) 592-2919
www.exeterchamber.com

Before the arrival of settlers, the Exeter area was part of a vast plain where elk, antelope, and deer grazed. Native Americans lived in the oak forest two miles north of the present town. In 1888, as the railroad carved its way through the southern San Joaquin Valley, towns grew up along the route. D. W. Parkhurst, representing the Southern Pacific Railroad, bought land from an early settler, and Exeter was born, named after the same town in England, Parkhurst's native country.

The development of water resources and the planting of fruit trees and grape vines brought growth to the community. Cattle ranching was also an integral part of Exeter's history. The Gill Cattle Company of Exeter was established in the late 1800s and is still in operation. Once the largest cattle ranching business in the United States, it owned or leased more than six million acres in nine western states. Claiming the finest navel oranges in the world, Exeter calls itself the "Citrus Capital of the World."

The Exeter Murals

1: Orange Harvest
2: Packing Ladies
3: The Emperor Grape Festival
4: Cattle Drive Down Rocky Hill
5: Yokuts Harvest
6: Poppies and Lupine
7: Mural Map
8: From Foundry to Field
9: Leta and Hawtoy
10: 4th of July in Exeter
11: Exeter Fruit Labels
12: Our Town, circa 1925

13: Golden Harvest
14: The People Behind the Label
15: Tracks of Time
16: Timber Trail
17: Passport to Paradise
18: Yokohl Brand
19: The Firebaugh Kids
20: Hometown News
21: Kiwanis Wading Pool
22: Lincoln Recess, circa 1899
23: Exeter Road Race, circa 1916

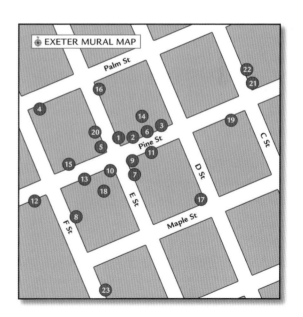

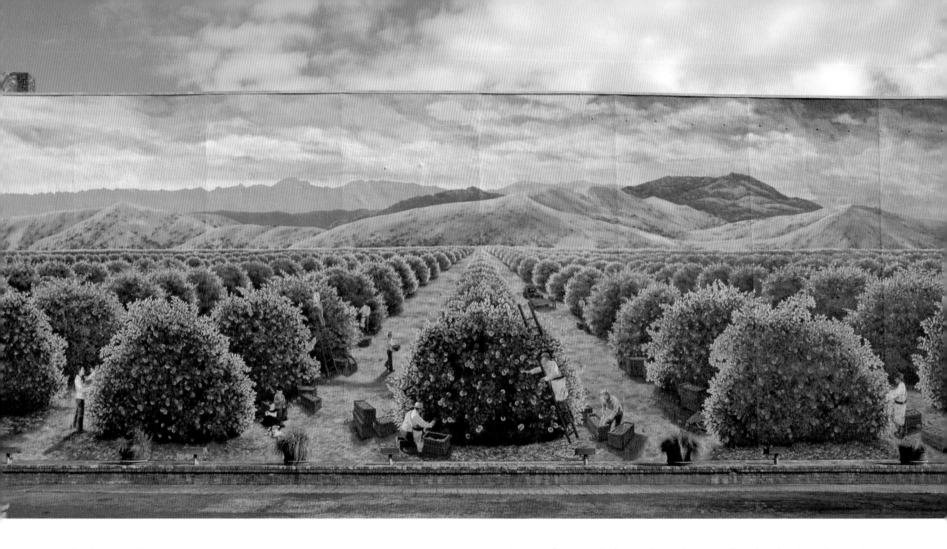

1. Orange Harvest

100' x 35', Pine and E Streets, Colleen Mitchell-Veyna with
Morgan McCall, 1996

Exeter's first mural, the product of two excellent local artists, shows citrus
pickers in the 1930s. Back then, families worked together while their children
played nearby. The mural overlooks Mixter Park in downtown Exeter.

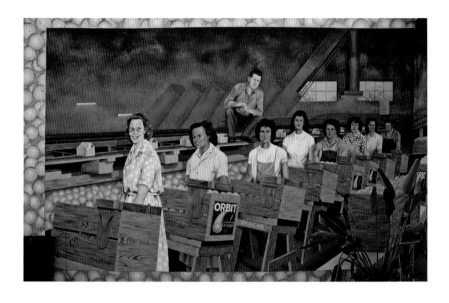

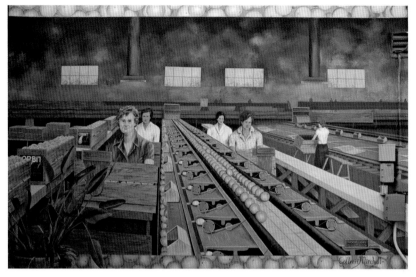

2. Packing Ladies *(top left and top right)*
34' x 11', just south of Orange Harvest mural,
Colleen Mitchell-Veyna, 1997

At the Exeter Citrus Packing House, circa 1950, women pack and grade oranges harvested from the fields and loaded onto grading belts. Foreman Bud Berger keeps a watchful eye.

3. The Emperor Grape Festival *(bottom)*
83'9" x 13', Pine and D Streets, **John Ton, 1997**

The mural salutes a long-running festival that began in 1913 when women from the Presbyterian Church put on a Chrysanthemum Fair with a carnival and a children's parade. By 1931 the event went by the name Emperor Grape Festival. It is now called the Exeter Fall Festival.

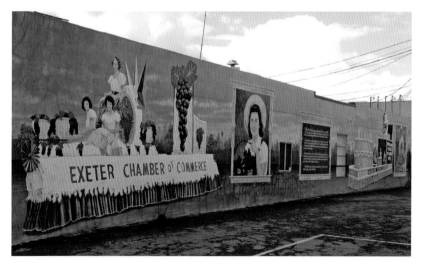

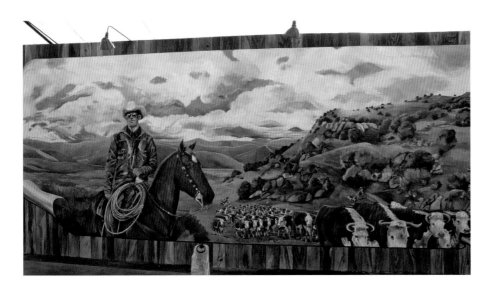

4 . Cattle Drive Down Rocky Hill *(top)*

17' x 6'7", 140 E. Palm Street, Nadi Spencer, 1997

Adolph Gill brings a herd of cattle around Rocky Hill. The Gill Cattle Company of Exeter, established in the late 1800s, is still in operation. The curled-up corner is a trompe l'oeil detail.

5. Yokuts Harvest *(bottom)*

30' x 11', Pine and E Streets, Ben Barker, 1997

Yokuts collect sour berries during the spring in an oak forest near Exeter. The muralist has taken care to illustrate the intricate artistry of the Yokut baskets.

6. Poppies and Lupine *(next page)*

16' x 12', East of Packing Ladies mural, Varian Mace, 1998

Native poppies and lupine occupy the foreground, and the Kaweah River leads the eye from the foothills into the Sierra Nevada. The scene shows the river before it was dammed to create Lake Kaweah, about ten miles northeast of Exeter en route to Sequoia and Kings Canyon National Parks.

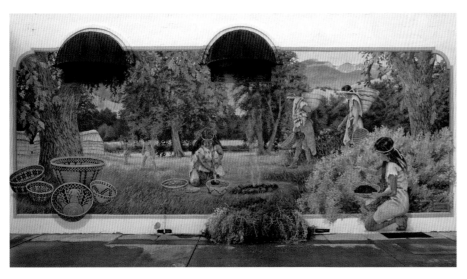

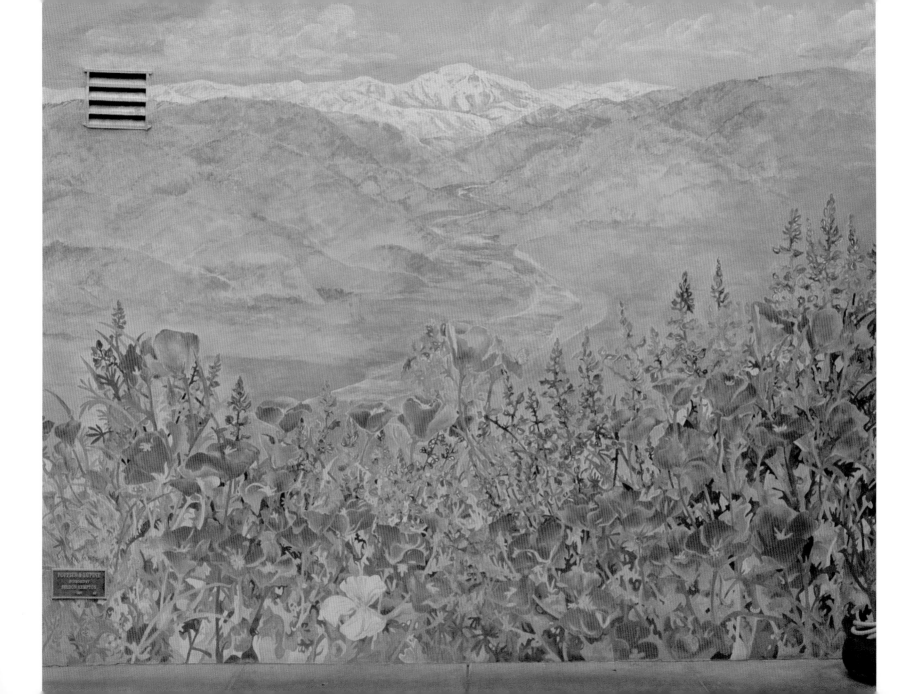

POPPIES & LUPINE
by commission
SHERON KEMPTON

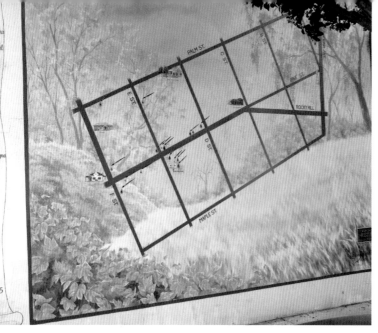

7. Mural Map *(top)*

18'9" x 11'9", 119 S. E Street, ongoing project,
Colleen Mitchell-Veyna

This map of the town's murals is amended as new murals are completed.

8. From Foundry to Field *(bottom)*

60' x 24', 125 S. F Street, Ken Cardoza, 1998

The three panels depict the history of Waterman Industries, a foundry established in 1912 to design and manufacture irrigation equipment. If you take the time to study the mural, you'll find a shoe, the letter W, and an outhouse.

9. Leta and Hawtoy *(left)*

9'6" x 16', 207 E. Pine Street,
Ivonne Nagel, 1998

Leta and Hawtoy, shown in their native Wutchumna dress, lived near Exeter and attended Exeter schools. Leta completed two years of work in one and was among the top students in her class.

10. 4th of July in Exeter *(right)*

7' x 15', E Street near Pine Street,
Gary Kerby, 1999

"Lion John Schultz" is honored for fifty years (1946–1996) of service to Exeter and the surrounding communities and for his work as chief pyrotechnician at the annual Lions Club fireworks on July 4.

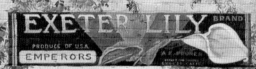
EXETER LILY BRAND
PRODUCE OF U.S.A.
EMPERORS

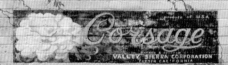
Corsage
PRODUCE OF U.S.A.
VALLEY SIERRA CORPORATION
EXETER CALIFORNIA

ORBIT BRAND
California Oranges
EXETER
CITRUS
ASSOCIATION
EXETER
CALIFORNIA

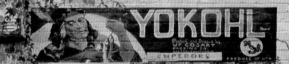
YOKOHL Brand
U.F. COSART
PACKING CO.
EMPERORS
PRODUCE OF U.S.A.

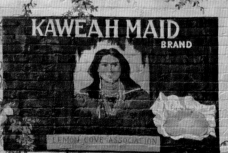
KAWEAH MAID BRAND
LEMON COVE ASSOCIATION

RED MULE BRAND
PRODUCE OF U.S.A.

BASKET Brand
GROWN AND PACKED BY
LEMON COVE ASSOCIATION
LEMON COVE
TULARE COUNTY CALIFORNIA

FRUIT LABELS

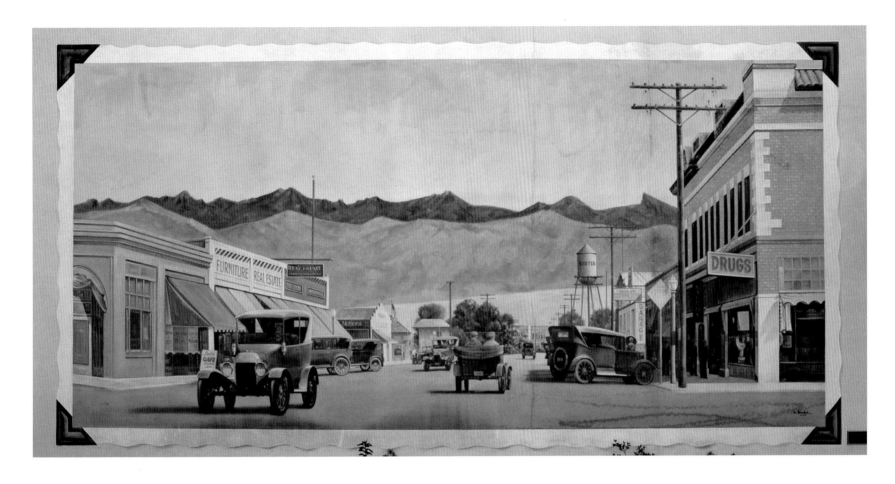

11. Exeter Fruit Labels *(previous page)*

20' x 15', True Value Hardware, 221 E. Pine Street, Lola Collins, 1999

The packing crate labels are all from Exeter businesses.

12. Our Town, circa 1925 *(above)*

24' x 16', Bank of America, 100 E. Pine Street, James Fahnestock, 1999

Resembling an old photo in an album, the mural shows Pine Street early in the 1900s. Images of George Washington and Mickey Mouse are tucked into the image.

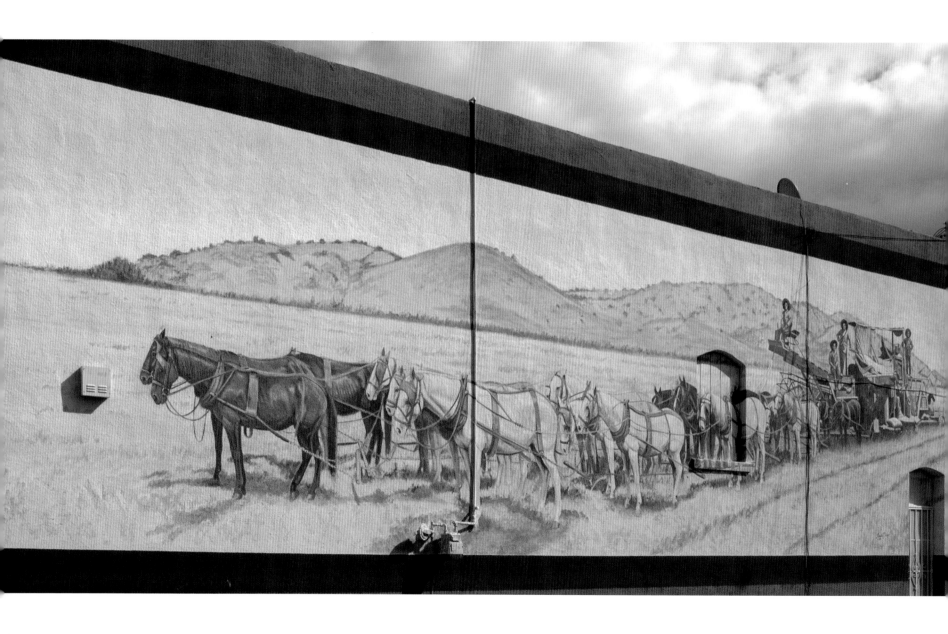

13. Golden Harvest *(previous page)*
60' x 24', 158 E. Pine Street, Claudia Fletcher, 2000

Men from local families harvest wheat in Mehrten Valley circa 1915.

14. The People Behind the Label *(top)*
15' x 20', Pine Street between D and E Streets, Chuck Caplinger, 2000

The artist has hidden images of a black bear and a dachshund in the grape harvest scene.

15. Tracks of Time *(bottom left and bottom right)*
78' x 25', F and Pine Streets, Michael Stanford, Yuri Somov, and Matt Hemsworth, 2001

Exeter was built around railroads. The earliest train in this mural appears on the left: a 1907 Visalia electric motor coach. Engine 502, in the center, is one of the first diesel locomotives, and on the right is a newer version of the 502 with engineer Charles Kirkman. Incongruous images are woven into the mural: Buzz Lightyear, Dorothy and friends from the *Wizard of Oz*, a monkey, a wolf, Darth Vader, and the dog from *Little Rascals*.

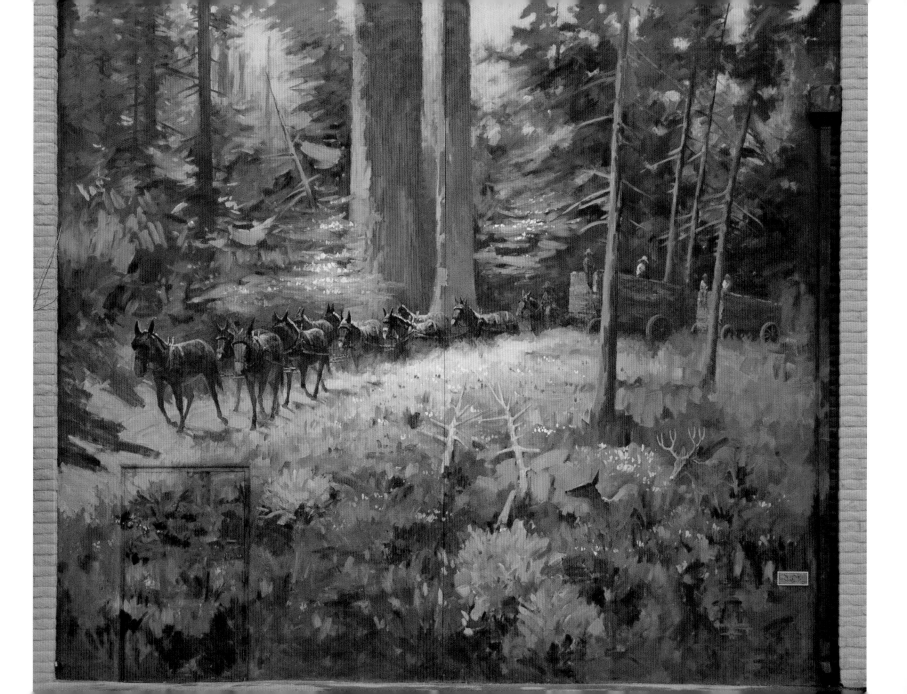

16. Timber Trail *(previous page)*

26' x 22', E Street near Palm Street, Martin Weekly, 2001

The Sierra Nevada supplied Exeter with wood in the late nineteenth and early twentieth centuries. Here, a load of milled lumber leaves Atwell Mill just below Mineral King in what is now part of Sequoia National Park. This painting has several well-hidden images: a quilt, a 35mm Nikon camera, an American flag, and the names "Dolly" and "Walter Weekly."

17. Passport to Paradise *(below)*

38' x 10'6", Maple and D Streets, Jeff Crozier, 2002

At one time, an archway spanned Highway 65 welcoming visitors to "Exeter, Gateway to Sequoia National Park" as they drove through the orange groves. The mural features three hidden images: a bear, a motorcycle, and a bear paw.

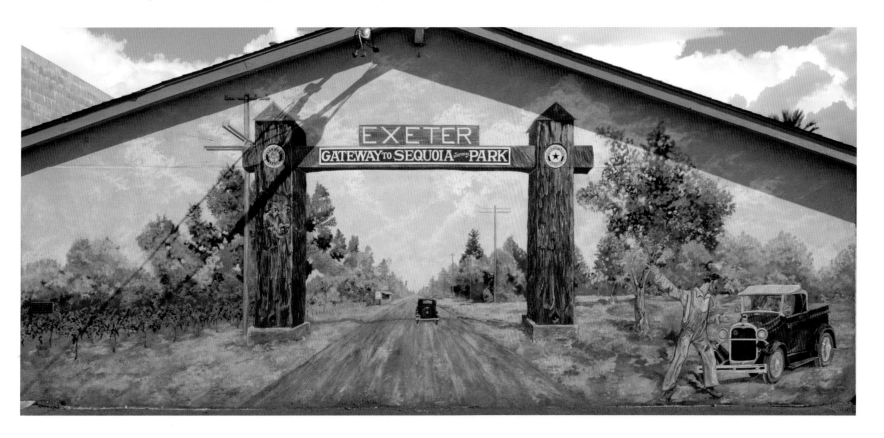

18. Yokohl Brand *(top)*

16'6" x 15', alley between E and F Streets south of Pine Street,
Gary Kerby, 2002

Concealed within this brilliantly colored reproduction of an orange crate
label are five images: the letters xoxoxo, the number 34, a heart, a cowboy
boot, and eyes.

19. The Firebaugh Kids *(bottom left)*

22' x 11', Pine and C Streets, Roger Cooke, 2002

The children of early settler John Firebaugh haul a wagon of milk from the
dairy to the creamery in about 1915. A face is hidden in the tree.

20. Hometown News *(bottom right)*

24' x 15', Exeter Sun Building, 120 N. E Street, Gary Kerby, 2003

The newsroom of the Exeter Sun was a busy place in the 1920s, as the staff
worked to edit copy and set type for an edition of the paper. A cowboy
boot and a sunburst can be found in the mural.

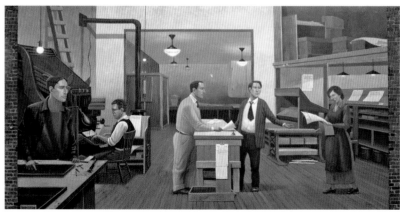

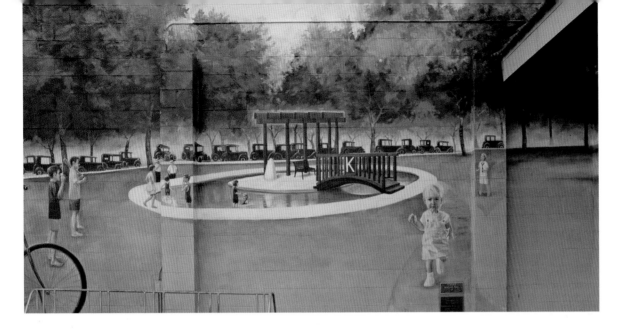

21. Kiwanis Wading Pool *(top)*

18' x 14', 362 E. Pine Street,
Glenn Hill, 2004

The wading pool in the city park, still used in summer, was built by the Kiwanis Club and dedicated in 1926. Look for the Native Americans, the bears, and a World War II soldier in the scene.

22. Lincoln Recess, circa 1899 *(bottom)*

50' x 15', 362 E. Pine Street,
Bob Thompson, 2006

School children play various games at recess at the old Lincoln Elementary School.

97

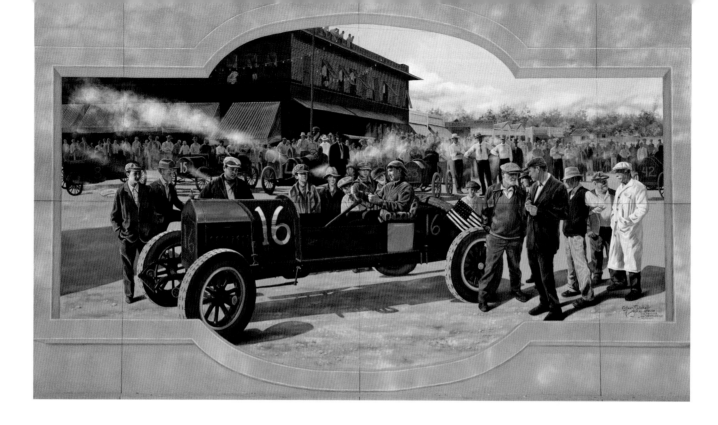

23. Exeter Road Race, circa 1916

40' x 20', 250 S. F Street, Colleen Mitchell-Veyna, 2006

Drivers and spectators get ready for a road race through downtown Exeter in the early 1900s. Local celebrities Wes Clover and Steve Ooley, as well as members of the artist's family, are in attendance. Look for a hidden polar bear, numbers, and a child holding a bear—all symbols from the popular television program *Lost*.

OTHER THINGS TO DO

· Kaweah Oaks Preserve: The nature trails allow visitors to see the central valley's endangered ecosystem of oak trees, cottonwoods, ash trees, and sycamores, along with local wildlife.

· Lake Kaweah: This lake in the Sierra Nevada foothills is great for boating, fishing, swimming, and waterskiing.

· Hogwallow Preserve: The mounds of soil, or hogwallows, in this preserve are about 1.5 million years old.

LINDSAY

Lindsay Chamber of Commerce

133 West Honolulu Street, Suite E, Lindsay, CA 93247

(559) 562-4929

http://chamber.lindsay.ca.us

Lindsay Mural and Public Art Society

915-N S. Strathmore Avenue, Lindsay, CA 93247

www.lindsaymurals.org

Captain Arthur J. Hutchinson of the British army, known as the founder of Lindsay, came to the area in 1889. He bought two thousand acres and formed the Lindsay Land Company. The town site was laid out by Hutchinson and others in the community and named for his wife, Sadie Lindsay Patton Hutchinson.

In the twentieth century, Lindsay became a successful agricultural community with both citrus fruit and the famous Lindsay olives as the most predominant crops. Over the decades, the agricultural economy continued to grow. Then, in December 1990, disaster struck when the local citrus industry was devastated by the worst freeze ever to hit the state. The entire crop was wiped out. In addition, Lindsay Olive Growers, the city's largest employer, closed and filed for bankruptcy.

In response Lindsay did a remarkable thing. Acknowledging the seriousness of its plight, the town conducted a mock funeral.

The Lindsay Murals

1:	Roadside Service, Two Bits a Pull	11:	Art Imitating Life, Imitating Art
2:	The Soda Fountain	12:	Discovery
3:	American Spirit	13:	Standing in Line
4:	Birth of Modern Irrigation	14:	Laurel and Hardy
5:	Charro Traditions	15:	Butterfield Overland Stage
6:	The Packing Shed	16:	Borax
7:	Wildlife	17:	Dr. Annie Bond
8:	Taylor and Son	18:	High Sierra Pack Trip
9:	Quail Lookout	19:	Troop 1
10:	Honor Guard Parade	20:	Decades of Quality Citrus

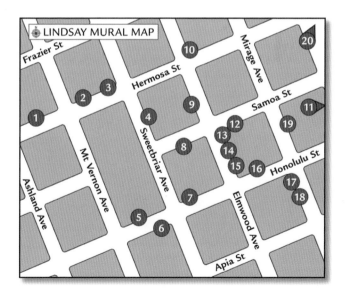

LINDSAY MURAL MAP

Mourners walked alongside a horse-drawn wagon carrying a casket filled with frozen citrus and other items associated with the downturn. At a local park, the casket was buried, eulogies were given, and Lindsay's immediate past was laid to rest. Lindsay then set out to diversify its economy. One way to do this was through tourism and a strong public art program, which was developed with the Lindsay Mural and Public Art Society.

1. Roadside Service, Two Bits a Pull *(bottom)*

35' x 11', Mike Butler's Garage, 301 W. Hermosa Street, Gary Kirby, 1999

This mural is based on a poem by Mike Butler that tells the story of local townsperson John Fredricks, who, in the time before tow trucks, would pull stuck Model T Fords out of the mud with his team of horses for the reasonable fee of two bits.

2. The Soda Fountain *(top)*

17' x 11', Realty Office, 295 W. Hermosa Street, Nadia Spencer, 2000

When the mural was painted, Doug Aitchison operated Royal Hawaiian Ice out of the building. The current occupant continues to support the mural by keeping the light on at night.

3. American Spirit *(next page)*

36' x 24', Suntreat Packing House, Hermosa Street and Sweetbriar Avenue, Wei Luan, 2002

Lindsay commissioned the mural as the city's tribute to the efforts of first responders like those who served in the 2001 World Trade Center tragedy. A real flag and flagpole protrude from the wall, and pieces of concrete and steel debris are on the ground in front of the mural.

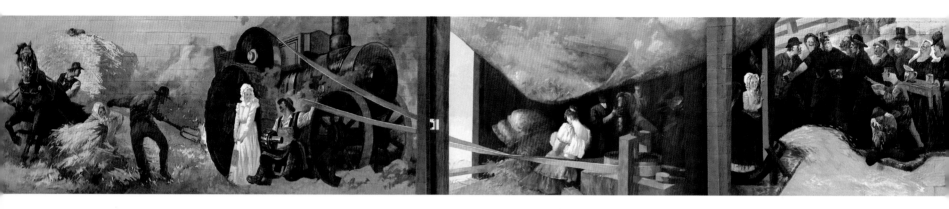

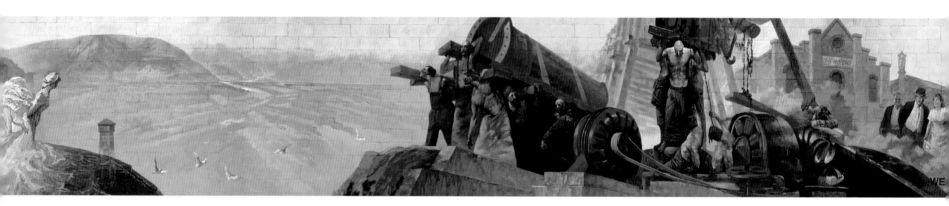

4. Birth of Modern Irrigation

120' x 10', Southern California Edison Substation, Hermosa Street and
Sweetbriar Avenue, Wei Luan, 2003

This epic narrative depicts the development of modern irrigation,
beginning in 1890 when John Cairns came to the Lindsay area and
began growing tens of thousands of acres of grain. Eventually he
determined that a well could be dug deep into the ground for water to
pump out and be used to support citrus and other fruit trees. On June 26,
1899, Mt. Whitney Power Company provided the power through the
Lindsay substation for the first large-scale electric-power irrigation pumping
project in the United States.

5. Charro Traditions *(top)*

60' x 15', Cal Citrus, Honolulu Street and Mt. Vernon Avenue,
Roger Cooke, 2006

The centuries-old *charreada* is an event where horsemen, especially the highly skilled *charros*, show off their expertise. Nowadays, women, or *charras*, also compete in specific contests. Lindsay has a rich *charreada* history, as both the *charros* and their horses have trained at several local ranches.

6. The Packing Shed *(bottom)*

100' x 14', Lo Bue Packing House, Honolulu Street and
Sweetbriar Avenue, Gary Kirby, 1999

Included in this orange-harvesting scene are tramps being interviewed for employment. The painted sign replicates one that encouraged tramps to stop in Lindsay. The man pedaling a bicycle-like apparatus is powering a belt that carries the oranges to an automatic sizer and into bins. There was no refrigeration then, and most of the crop was shipped by rail.

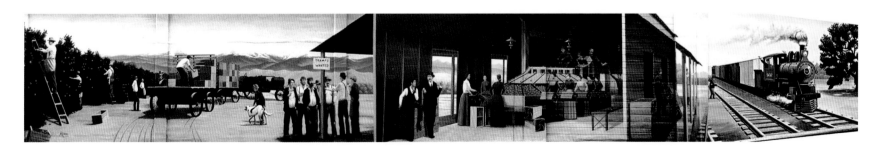

103

7. Wildlife *(top)*

67' x 11', Gallery Park, 155 W. Honolulu Street,
Colleen Mitchel-Veyna, 2000

Colleen Mitchell-Veyna painted the basic outline, then invited volunteers to help her finish creating this mural depicting flora and fauna native to the Lindsay area. The plants in the park where the mural is located are also natives.

8. Taylor and Son *(bottom)*

20' x 10', alley east of Sweetbriar Avenue at Samoa Street,
Mike Kohler, 2003

In the late 1950s Wilbur Taylor and his son Tom N. Taylor opened a garage in this location. They were good mechanics known for their talent in building hot rods. Tom, taking advantage of his initials, was known as "TNT."

9. Quail Lookout *(top)*

15' x 15', Bank of America, 215 N. Elmwood Street, Steve Ball, 2004

The California quail, the state bird, is found in rural Lindsay. The males perch on posts or tree stumps to serve as lookouts for the covey.

10. Honor Guard Parade *(bottom)*

42' x 10', Tienken Realty Building, 101 E. Hermosa Street, Colleen Goodwin Chronister, 2001

The mural, based on a photograph of a parade that took place in Lindsay, includes images related to the town's early days. The view is of the buildings from the corner of Honolulu and Elmwood, looking east toward the mountains.

11. Art Imitating Life, Imitating Art *(previous page)*

22' x 14', Lindsay Library, 165 N. Gale Hill Avenue, John Pugh, 2001

The mural was originally created for the Café Trompe l'Oeil in San Jose, California. When the café closed in 2006, the Lindsay Mural and Public Art Society arranged to have it moved to the town library, where the woman at the table reading, part of the trompe l'oeil painting, is perfectly at home.

12. Discovery *(top)*

40' x 30', Lindsay Community Theater, 190 N. Elmwood Avenue, Josie Figueroa, 1997

The actor depicted, Clark Gable, spent time in Lindsay, often staying at the old Mt. Whitney Hotel. The woman is based on a well-known Hispanic actress, Linda Crystal, chosen to represent the town's cultural diversity.

13. Standing in Line *(bottom left and bottom right)*

46' x 7', Lindsay Community Theater, 190 N. Elmwood Avenue, Nadi Spencer, 2001

The scene of patrons waiting to enter the theater faces Samoa Street and wraps around the building to face Elmwood Avenue.

14. Laurel and Hardy *(top)*

10' x 6', Lindsay Community Theater, 190 N. Elmwood Avenue, Mike Kohler, 2000

Passersby encounter life-size images of the early movie stars.

15. Butterfield Overland Stage *(bottom)*

45' x 10', Sundance Studios, 160 N. Elmwood Avenue, Art Mortimer, 2003

The famous stagecoach stopped close to downtown Lindsay from 1858 to 1861 on the first overland mail route from St. Louis to San Francisco. Volunteers painted the mural-in-a-day under the direction of Art Mortimer, during the 2003 California Mural Symposium.

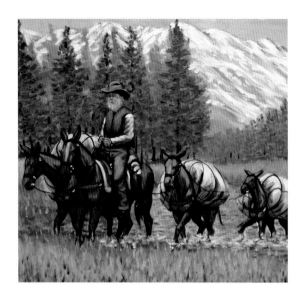

16. Borax (left)

12' x 8', 143 E. Honolulu Street, artist unknown, year unknown

From 1900 to 1940 the Borax Company went to towns and had murals painted as advertisements. Tucked away at the entrance to a downtown alley by the Mount Whitney Hotel, this billboard mural probably originated as an advertisement, but was repainted in the early 1990s and is now considered art.

17. Dr. Annie Bond (middle)

14' x 14', Dr. Chiurazzi's Dentist Office, 133 S. Mirage Avenue, Don Gray, 2001

Dr. Annie Laurie Bond practiced medicine in Lindsay for forty-two years, at a time when few women became physicians. She founded the town's first hospital and was credited with saving many lives during the deadly influenza epidemic of 1918–19.

18. High Sierra Pack Trip (right)

8' x 8', Dr. Chiurazzi's Dentist Office, 133 S. Mirage Avenue, Mike Kohler, 2003

This mural of a typical old-timer making his way through the Sierra Nevada was painted during the Mural Showdown at the 2003 California Mural Symposium. Ten professional muralists each completed an eight-by-eight-foot scene of their choosing. The works were judged and then auctioned to symposium attendees.

19. Troop 1

16' x 8', 150 N. Mirage Avenue, Josie Figueroa, 2007

Boy Scout Troop One, one of the first troops in the state, was chartered in Lindsay in 1912. The first scoutmaster was local accountant Walter E. Hind.

The muralist and the Lindsay Mural and Public Art Society worked with Eagle Scout candidate Josh Jones to complete this mural of three modern-day scouts in front of a sepia photograph of a Troop 1 outing in the Sierra Nevada in 1915.

20. Decades of Quality Citrus *(top and bottom)*

80' x 10', Suntreat Citrus Packing, 714 E. Tulare Road,
Roger Cooke, 2007

Wrapping around the northwest corner of the Suntreat facility,
the mural tells the story of the local citrus industry, from the
early days of transporting oranges by horse-drawn wagon
through to the current use of wind machines to protect the
groves from frost and the reliance on eighteen-wheel trucks to
carry the crop to market.

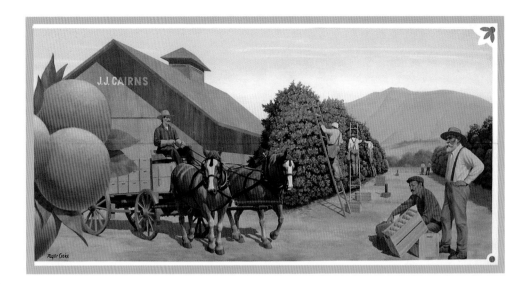

OTHER THINGS TO DO

· McDermont Field House and Sports Center:
 Located in Lindsay, the regional recreation center,
 a former packing house, has more than four acres
 of fitness facilities, including indoor soccer fields,
 basketball and volleyball courts, an indoor track,
 and a laser tag center.

· Three Sisters Farmstead Cheese: Visitors can tour
 this modern cheese facility and learn how several
 different varieties of cheese are made.

· Sequoia and Kings Canyon National Parks:
 The parks have immense mountains and deep
 canyons—plus giant sequoias, some of the
 world's largest trees.

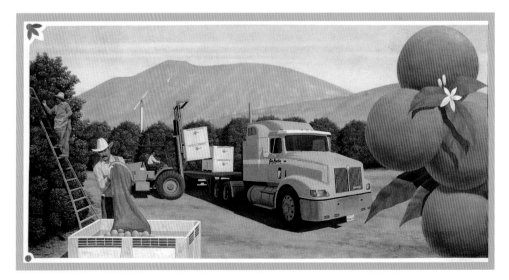

PORTERVILLE

Porterville Chamber of Commerce
93 N. Main Street, Suite A
Porterville, CA 93257
(559) 784-7502
www.chamber.porterville.com

The gold rush of 1848 brought a large migration through the area, and some individuals took notice of the fertile land and decided to stay. In time, a small commercial area developed. Royal Porter Putnam arrived in 1860, built a hotel and store, and became so influential that the town was named after him. Residents used his middle name, as another Putnam family also lived in the area. Porterville, like its neighbors to the north, Exeter and Lindsay, is noted for its citrus groves. Other industries have recently moved in, giving the town a diverse economic base.

The Porterville Mural Project, under the aegis of the Porterville Arts Association, intends to add more murals to the town gallery and thereby become a significant element in the large mural community extending to the north in Lindsay, Exeter, and Tulare.

The Porterville Murals

1. The Centennial Mural
2. A Celebration of Iris

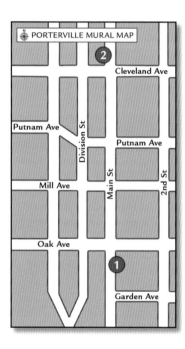

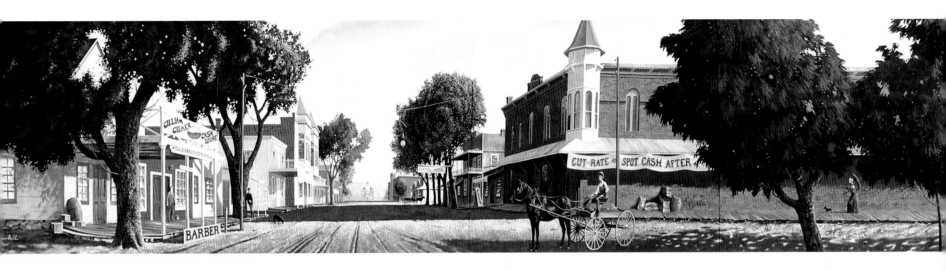

1. The Centennial Mural

70' x 20', Main Street and Garden Avenue, Steven Louis Ball, 2002

Commissioned for the Porterville Centennial Celebration, the mural shows
Porterville in 1902. The artist and two local historians, Bill Horst and
Jeff Edwards, did extensive research to ensure accuracy of the architectural
details. At the center of the mural is the Morton Street School. Also
depicted is the first streetlight, strung across Main Street.

2. A Celebration of Iris

10' x 10', Main Street and Cleveland Avenue,
Steven Louis Ball, 2007

In the middle of the 1900s, Porterville resident Bill Shortman gained national and international awards for his iris hybrids. In 1963 Porterville named the iris the town's official flower. Twenty years later, Shortman and two other iris aficionados began breeding irises commercially. Porterville is now home to the world's largest distributor of reblooming irises. The Porterville Iris Festival is held annually on the fourth Saturday in April.

OTHER THINGS TO DO

· Zalud House: Built in 1891 and furnished with the original owner's possessions, it is one of the few homes of the period that has not undergone remodeling. From the time the house was built to its dedication as a historical monument, only the Zalud family lived there.

· Porterville Museum: Housed in the 1912 Southern Pacific Depot, the museum displays the handiwork of the local Yokut Indians, as well as pioneer artifacts, vintage agriculture equipment, and historical mosaics.

5 SOUTH CENTRAL COAST MURAL ROUTE

Lompoc · Santa Paula

Santa Maria

**South Central Coast
Mural Route**

• Santa Maria

Santa Paula

Lompoc

San
Francisco

Los
Angeles

LOMPOC

Chamber of Commerce
111 S. I Street
Lompoc, CA 93436
(805) 736-4567
www.lompoc.com

Lompoc Mural Society
PO Box 2813
Lompoc, CA 93438
www.lompocmurals.com

The Chumash lived in the region for nearly ten thousand years prior to the arrival of European settlers. *Lompoc* is a Chumash word meaning "land of many lakes" (and is pronounced Lom-POKE, never Lom-POCK!). La Purisima Mission, dating to 1787, was the earliest European settlement in Lompoc Valley. The restored mission is now a state historic park. Nearly one hundred years later, after California

The Lompoc Murals

1: Flower Industry
2: Mission Abstract
3: Diatomaceous Mining
4: Temperance
5: Early Education
6: Ethnic Diversity
7: Lompoc's First Fire Chief
8: La Purisima Mission
9: Latina Esprescion
10: Lompoc's Mission Vieja
11: An Artist's Cottage
12: Rudolph Mansion
13: The Price of Freedom
14: Flowers of the Valley
15: History of Medicine in
 the Lompoc Valley

16: Chumash Indians
17: Main Street 1900–1930 *(in storage)*
18: Steelhead Fishing in the Santa Ynez River
19: Domingo's Blacksmith Shop
20: History of Agriculture in the Lompoc
 Valley *(in storage)*
21: Great Lompoc Gold Rush
22: Great Floral Flag
23: The Lighthouse at Point Conception
24: Flora and Fauna of the Lompoc Valley
25: 50 Years of Flowers and Memories *(in storage)*
26: Last of the Titans: Missile Magic *(in storage)*
27: Fields of Gold
28: Remembering Clarence "Pop" Ruth and
 the Chumash Indian Heritage of Lompoc
29: Monarch Magic

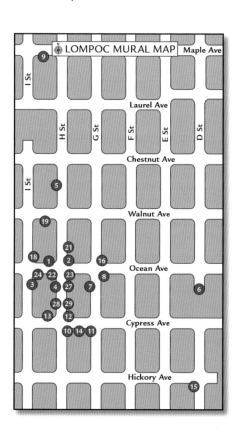

achieved statehood, the Lompoc Valley Land Company was formed and undertook the settlement of Lompoc Valley as a temperance colony. The town eventually lost its temperance mantle and was incorporated on August 13, 1888. The economy is essentially agricultural but has become diversified with the establishment of Camp Cooke Army Base (now Vandenberg Air Force Base).

The Lompoc mural program has been responsible for a wealth of murals. Lompoc, Lindsay, and Twentynine Palms were the founding members the California Public Art and Mural Society, dedicated to the growth of California mural towns.

1. Flower Industry (top)
52' X 11', 102 W. Ocean Avenue, Art Mortimer, 1989
Lompoc's first civic mural features portraits of important early growers and past and present workers, as well as flower fields and seed company sites.

2. Mission Abstract (bottom)
24' x 14', 104 E. Ocean Avenue, Lori Slater, 1989
This stylized mural depicts a portion of the entrance to Lompoc's first la Purisima Mission, located at what is now Locust Avenue and South F Street.

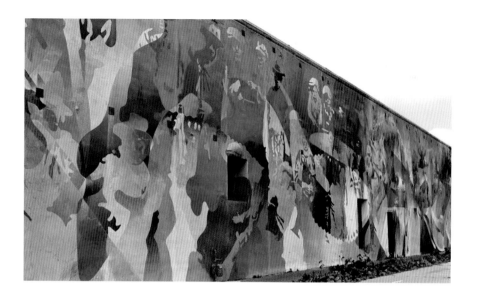

3. Diatomaceous Mining *(top)*
140' x 30', 111 S. I Street, Roberto Delgado, 1990

Mining diatomaceous earth has been a local industry for more than a century. One of the town's most artistically ambitious murals depicts the era when Lompoc Valley was beneath the sea and great masses of diatoms settled on the ocean floor. The reds signify the individual diatoms, and the blues represent aquatic forms taken from Chumash cave paintings. The two elements combine to create figures of miners from the early 1900s.

4. Temperance *(bottom)*
100' x 14', 137 S. H Street, Dan Sawatsky, 1992

Lompoc was founded as a temperance colony, but all the mobs of ax-wielding women could not keep liquor out of town. A fierce local housewife named Mrs. J. B. Pierce gathered a band of women to fight the evils of alcohol. In 1883 they were a part of a vigilante committee that strung a rope around a building, yanked it off its foundation, and pulled it for a block, liquor spilling out along the way.

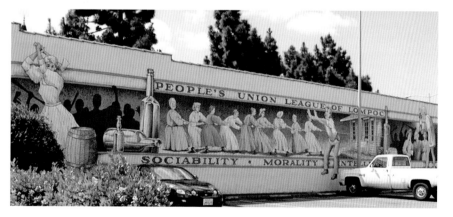

5. Early Education *(top)*

36' x 14', Bank of America, 215 N. H Street, Shirley Wallace, 1992

The one-room schoolhouse, Santa Rita School, was built in 1876 off what is now Highway 246 between Lompoc and Buellton. The children's images are taken from an 1884 class photo at another Lompoc school. The image in the cameo is Anne Calvert, Lompoc pioneer and schoolteacher.

6. Ethnic Diversity *(bottom)*

60' x 16', Lompoc Superior Court, 115 Civic Center Plaza, Richard Wyatt, 1993

The twelve large portraits celebrate people of various ethnicities who have played a role in local history, including prominent Lompoc black leader Louis Artis, Chumash Indian leader Juanita Centeno, and Gin Chow, the Chinese philosopher, farmer, and businessman whose lawsuit against Santa Barbara helped establish the foundation for California water rights law.

7. Lompoc's First Fire Chief *(top)*

32' x 16', Fire Station, 120 S. G Street, Pat Saul and Robert Saul, 1994

The first chief depicted here is Charles Everett, who served from 1915 to 1950. The little boy on the truck is Ed Everett, the chief's son.

8. La Purisima Mission *(bottom)*

41' x 11', 206 E. Ocean Avenue, Leonardo Nunez, 1995

The original mission, at F Street and Locust Avenue, was destroyed by a massive earthquake in 1812. It was rebuilt at the present site three miles northeast of Lompoc beginning 1813. The scenes from the mission's history include a complete reconstruction by the Civilian Conservation Corps during the 1930s.

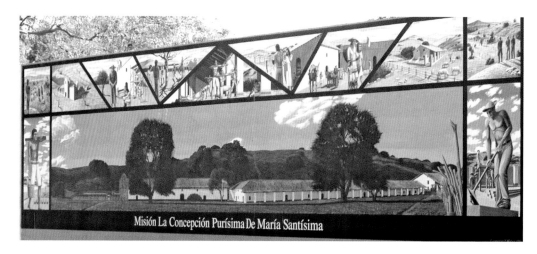

Misión La Concepción Purísima De María Santísima

9. Latina Esprescion *(top)*

39' x 16', 119 W. Maple Avenue, Leonardo Nunez
with students from Lompoc High School, 1995

The mural, centered around the Mayan temple of Chichen Itza, tells the story of Mexican people seeking to improve their lives. The leaders portrayed at the top made significant contributions to civil rights.

10. Lompoc's Mission Vieja *(bottom)*

48' x 12', Lompoc Museum, 200 S. H Street, Vicki Andersen, 1996

Mission la Concepcion Purisima de Maria Santisima was founded on December 8, 1787. More than a hundred adobe buildings were erected, a water system was developed, crops were planted, and livestock numbering in the tens of thousands roamed the valley. On December 21 in 1812, also known as el Año de los Temblores, a powerful earthquake followed by rains and flooding destroyed most of the buildings. The ruins of the original mission can be seen not far from the museum.

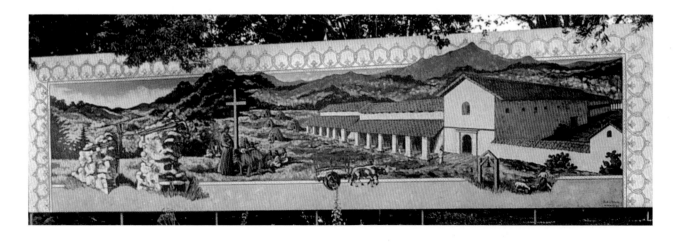

11. An Artist's Cottage *(top)*

**Cypress Gallery, 119 E. Cypress Avenue,
Linda Gooch and Vicki Andersen, 1998**

Cypress Gallery is headquarters of the
Lompoc Valley Art Association. The mural
covers all four walls of the building.

12. Rudolph Mansion *(bottom)*

**80' x 13', 101 W. Cypress Avenue,
Leonardo Nunez, 2000**

Lompoc's first mayor, Harvey Rudolph, lived
in a beautiful three-story Victorian-style
house at Ocean Avenue and E Street. It was
bulldozed in the early 1960s and replaced
by a grocery store that served the growing
number of workers at Vandenberg Air Force
Base, but the home lives on in this mural.

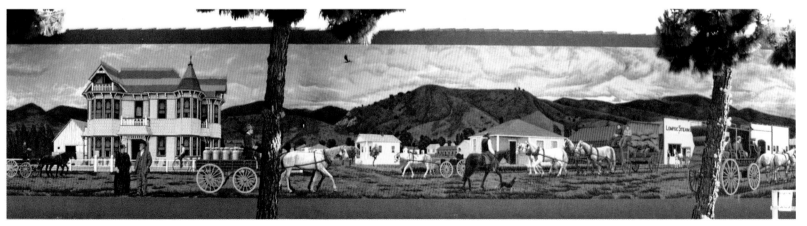

13. The Price of Freedom *(top)*

100' x 30', 125 S. H Street, Eliseo Art Silva, 2000

This large-scale work recognizes the American men and women who served, fought, and died in the fifteen wars and conflicts of the twentieth century. An estimated 293,131 were killed, and another 1.3 million were wounded. The centerpiece is an eagle wing, each feather of which represents one of the wars or conflicts labeled at the bottom of the mural.

14. Flowers of the Valley *(bottom)*

Cypress Gallery, 119 E. Cypress Avenue, Vicki Andersen, 2001

Each of eleven murals, painted on the garage doors, carries a different flower grown in the Lompoc Valley. A trompe l'oeil woman and a cat appear to hide in an alcove.

123

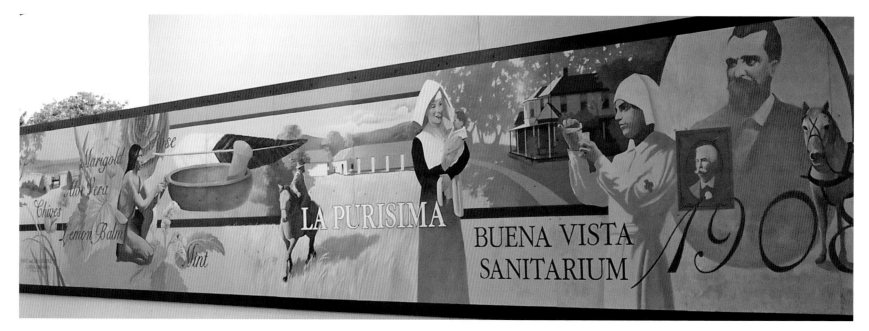

15. History of Medicine in the Lompoc Valley *(previous page)*

124' x 8', Lompoc Hospital Entryway,
508 E. Hickory Avenue, David Blodgett, 2005

The 120-foot mural reaches back some eight thousand years to when the Chumash Indians first occupied the area. The visual chronology proceeds with depictions of Lompoc's earliest hospital, dated 1908, and other facilities, until the opening of the Lompoc Hospital in 1943. Portraits honor individuals who played major roles in the medical community.

16. Chumash Indians *(top)*

48' x 12', 118 E. Ocean Avenue,
Robert Thomas, mural-in-a-day, 1992

Lompoc's first mural-in-a-day was painted by numerous volunteer artists working under the direction of Robert Thomas.

17. Main Street 1900–1930 *(bottom)*

48' x 12', Currently in storage, Art Mortimer, mural-in-a-day, 1999

The artist chose to present the historic scenes as sepia-toned photographs. The flagpole stood until World War II. The figure on the right is Harvey Rudolph, the town's first mayor.

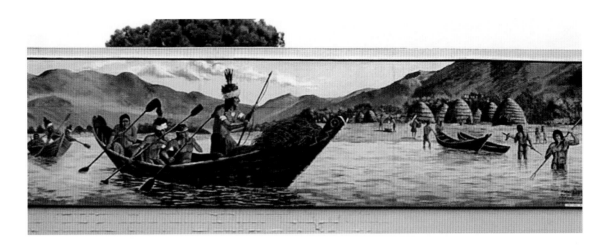

18. Steelhead Fishing in the Santa Ynez River *(top)*

48' x 12', 123 W. Ocean Avenue, Roger Cooke, mural-in-a-day, 1994

Before the construction of Bradbury Dam at Cachuma Lake in 1953, the Santa Ynez River was one of the state's great steelhead fishing streams, drawing anglers who hoped to land one of twenty-pounders that came up the river.

19. Domingo's Blacksmith Shop *(bottom)*

48' x 12', 120 W. Walnut Street, Suzanne Cerney, mural-in-a-day, 1995

When this mural was painted, Domingo's was one of the few remaining blacksmith shops in California. The shop was also a social gathering place.

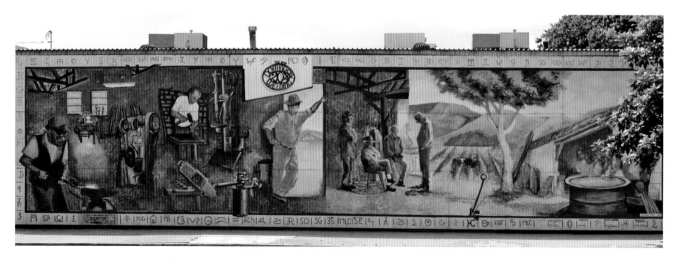

20. History of Agriculture in the Lompoc Valley *(top)*

48' x 12', Currently in storage, Vicki Andersen and Carol Oliveira, mural-in-a-day, 1996

The Lompoc Valley is said to have one of the most temperate climates on earth for agriculture. It was a highly productive apple-growing region around 1900. It has also been a major growing area for cherries, sugar beets, and flowers.

21. Great Lompoc Gold Rush *(middle)*

48' x 12', 135 N. H Street, Roger Cooke, mural-in-a-day, 1998

Lompoc's "Great Gold Rush" began in 1889 and took place from the mouth of the Santa Ynez River to Honda Creek. More than two hundred people were working claims by December 1889, but the gold began to peter out in the spring of 1890.

22. Great Floral Flag *(bottom)*

48' x 13', 131 S. H Street, Art Mortimer, mural-in-a-day, 1999

In 1941, during World War II, Bodger Seed Company of Lompoc created a special tribute by planting six hundred thousand larkspur and calendula flowers in the fields to the west of town below Lookout Point. The next spring, more than nine acres blossomed into a giant flag. The flag was replanted with different dimensions in the 1940s and 1950s, and once again in 2002.

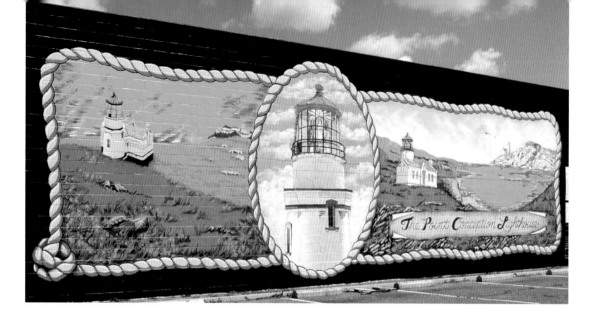

23. The Lighthouse at Point Conception *(top)*

52' x 14', 131 S. H Street, Vicki Andersen and Linda Gooch, mural-in-a-day, 2000

The lighthouse, completed in 1854, did not become operational until September 1855, when a Fresnel lens manufactured in Paris was installed. For over 150 years, the lighthouse has served as an important navigational aid along what is called the "graveyard of ships."

24. Flora and Fauna of the Lompoc Valley *(bottom)*

48' x 12', 111 W. Ocean Avenue, Art Mortimer, mural-in-a-day, 2001

This mural depicts animals and plants that are native to this area.

25. 50 Years of Flowers and Memories *(top)*

48' x 12', currently in storage, Nancy Phelps and
Sue Treuhaft, mural-in-a-day, 2002

The Flower Festival, held annually in the Lompoc Valley,
features a parade, a flower show, arts and crafts, and
a carnival.

26. Last of the Titans: Missile Magic *(bottom)*

48' x 12', currently in storage, Colleen Mitchell Veyna,
mural-in-a-day, 2000

The last of the Titan II launches took place at
Vandenberg Air Force Base.

27. Fields of Gold *(top)*

38' x 12', 126 S. H Street, Colleen Goodwin Chronister, mural-in-a-day, 2004

The sepia center showing the process of growing and harvesting seeds is surrounded by a sea of golden flowers.

28. Remembering Clarence "Pop" Ruth and the Chumash Indian Heritage of Lompoc *(bottom)*

48' x 12', 118 S. H Street, Colleen Mitchell-Veyna, mural-in-a-day, 2005

The territory of the Chumash Indians once stretched from Malibu to Morro Bay. Their maritime culture flourished for thousands of years prior to the arrival of Spanish explorers and missionaries. Clarence Ruth, a local educator and historian, was among the first to study the Chumash way of life. In the 1920s and 1930s, he collected and studied Chumash artifacts, as well as material from many other California tribes. Some of the objects depicted are on display at the Lompoc Museum.

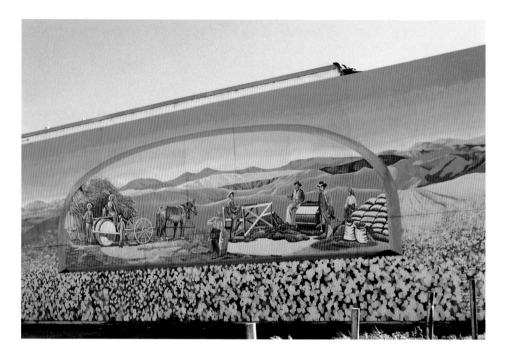

29. Monarch Magic *(next page)*

48' x 12', 118 S. H Street, Colleen Goodwin Chronister, mural-in-a-day, 2006

Lompoc's fifteenth mural-in-a-day depicts the monarch butterflies found in a stand of eucalyptus trees at Vandenberg Air Force Base.

OTHER THINGS TO DO

- Fabing-McKay-Spanne Historical House: The 1875 Victorian home was fully renovated and furnished by the Lompoc Valley Historical Society. The grounds include a blacksmith shop and a carriage house.

- Italian Stone Pines: This stand of trees, creating a canopy over South H Street, is classified as the largest grove of Italian stone pines outside the Mediterranean. Planted in 1940 by mistake, they are now valued at more than $3 million.

- Lompoc Museum: The building was constructed in 1911 as a Carnegie Library and served as a library until 1968. The museum focuses on the archaeology and history of the Lompoc Valley and Santa Barbara County.

- Old Town Lompoc Heritage Walk: Allow yourself at least an hour for this one-mile walk that takes you on a scenic tour of Old Town Lompoc with eighteen different stops. Maps are available at the chamber office.

- Vandenberg Air Force Base: Located seven miles west of Lompoc, the base is among the nation's most important military and aerospace installations. Tours are available.

- La Purisima Concepcion de Maria Santisima: Visit the ruins of the original mission, located at the south end of F Street. Pick up a map from the chamber of commerce.

- Artesia School House: Built in 1876, this was Lompoc's first country school, named after the nearby artesian wells. The Lompoc Museum and the Lompoc Valley Historical Society joined forces to furnish the school.

SANTA PAULA

Santa Paula Chamber of Commerce
200 N. Tenth Street, Santa Paula, CA 93060
(805) 525-5561 · www.santapaulachamber.com

The Murals of Santa Paula
1323 Say Road, Santa Paula, CA 93060
(805) 525-2824 · www.santapaulamurals.org

Heritage Valley Tourism Bureau
270 Central Avenue, Fillmore, CA 93015
(800) 700-1251 · www.heritagevalley.net

The picturesque city of Santa Paula, sixty-five miles northwest of Los Angeles and fourteen miles east of the Pacific Ocean, lies among the lemon, orange, and avocado orchards of the Heritage Valley. To the north are the rugged peaks of the Los Padres National Forest.

In 1890, after oil was discovered in the region, the Union Oil Company of California was incorporated in Santa Paula. The original Unocal offices have been refurbished and are occupied by the Santa Paula Museum of History. In the early 1900s, before the ascendance of Hollywood, Santa Paula was considered the center of the motion picture industry. Even today, Santa Paula is used frequently as a location for commercials, TV programs, and films.

The Santa Paula Murals

1: Transport in Time and Place: Trains, Planes, and Automobiles, 1890s–1940s
2: Our First Inhabitants: The Chumash Indians
3: Santa Paula Family Farms, 1880s–1930s
4: Santa Paula, Citrus Capital of the World
5: Main Street Santa Paula, circa 1910
6: Celebrating Santa Paula's Latino Culture
7: Discovering Black Gold in Santa Paula, 1860s–1950s
8: Celebrating Santa Paula's Artists and Architects
9: Honoring Founders and Pilots of Santa Paula Airport

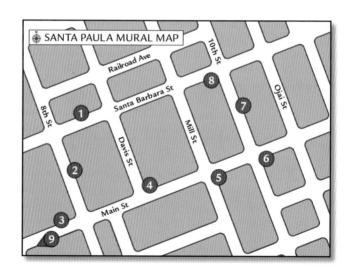

Santa Paula Airport, the oldest operating field in Ventura County, is known as the "Antique Airplane Capital of the World" because of the many historic and experimental aircraft based there.

The Murals of Santa Paula, the local mural society, has sponsored a gallery of murals depicting the history and culture of the area.

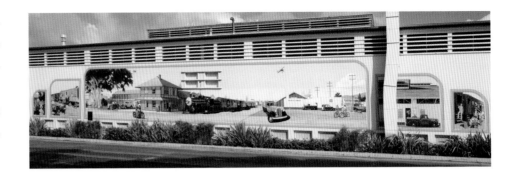

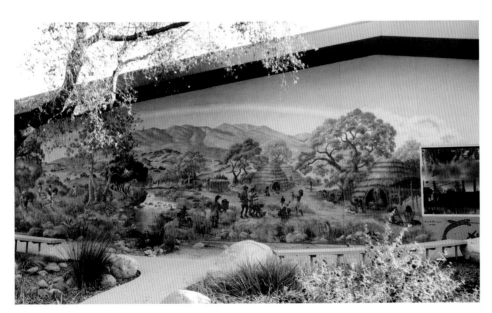

1. Transport in Time and Place: Trains, Planes, and Automobiles, 1890s–1940s *(top)*
Ventura County Agriculture Building, 815 Santa Barbara Street, Wendell Dowling, 2001

This mural centers on activities at the Southern Pacific Depot, built in 1887. The artist includes vehicles of different eras, such as a 1937 Hudson coupe, a 1934 Dodge panel truck, a 1937 Greyhound super coach, and a 1931 Indian motorcycle. The left panel shows President Benjamin Harrison passing through Santa Paula in 1891. In the right panel, soldiers leave to serve in the Korean War.

2. Our First Inhabitants: The Chumash Indians *(bottom)*
Santa Paula Library, 119 N. Eighth Street, Ann Thiermann, 2000

Ann Thiermann researched the subject matter by hiking to the site of the Chumash village of Sisa in the foothills above Santa Paula and listening to local Chumash culture bearers. In the mural, she shows a grandmother sharing with her granddaughter stories of the history of the Chumash.

3. Santa Paula Family Farms, 1880s–1930s *(top)*

Bank of America, 715 E. Main Street, Chuck Caplinger, 2002

During the half century of local history covered in the mural, small family farms raised cattle and sheep and grew grains, lima beans, walnuts, and apricots. Inset scenes emphasize specific activities, such as roping cattle, preparing apricots for drying, and harvesting walnuts.

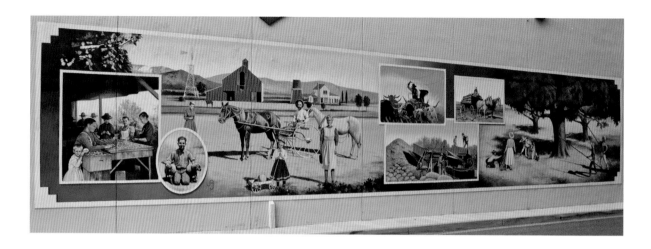

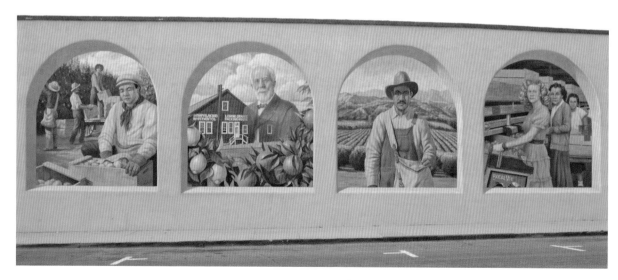

4. Santa Paula, Citrus Capital of the World *(bottom)*

Main and Davis Streets, Don Gray with son Jared Gray, 1999

Each scene highlights an aspect of the Santa Paula citrus industry from 1880 to 1940 (left to right): Japanese, Anglo, and Hispanic field workers in 1900 harvesting lemons; Santa Paula founder Nathan Blanchard with his first packing house; Latino fruit pickers; the significant role of women in packing houses in 1940.

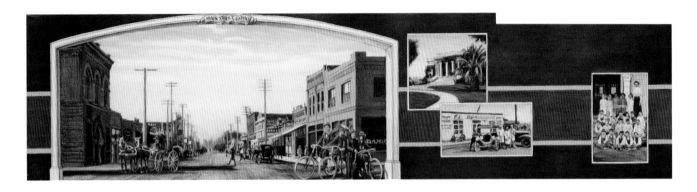

5. Main Street Santa Paula, circa 1910 *(top)*
Main and Mill Streets, Art Mortimer, 1998

Accompanying the view of Main Street from a century ago are vignettes showing the original Blanchard Library, built in 1910; children from the first elementary school, located nearby; and El Brillante Market, center of the Mexican community in Santa Paula at the time.

6. Celebrating Santa Paula's Latino Culture *(bottom)*
Main and Tenth Streets, Eloy Torrez, 2003

Members of the Latino community are represented in their many roles. Landmarks in the background are Our Lady of Guadalupe Church, circa 1929; Santa Paula High School bell tower, 1939; and the Main Street clock tower, 1905.

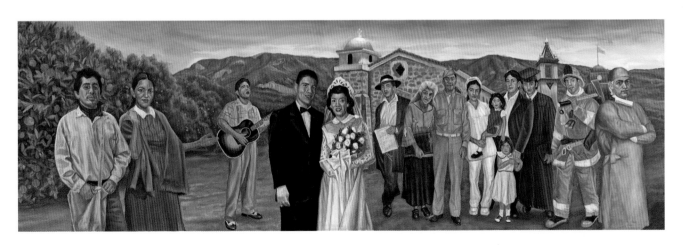

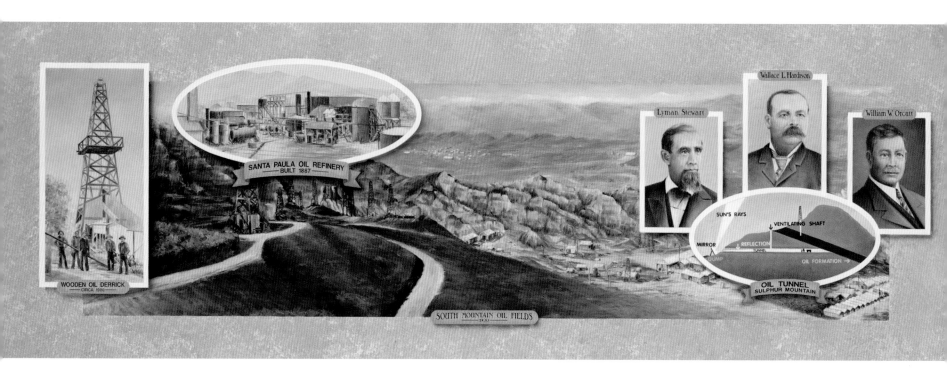

7. Discovering Black Gold in Santa Paula, 1860s–1950s

Century 21 Building, 123 N. Tenth Street, Jim Fahnestock, 2001

Lyman Stewart and Wallace Hardison, pictured here, discovered oil in
the area and formed Hardison & Stewart Oil Company in 1883. It became
Union Oil in 1890. William W. Orcutt grew up in Santa Paula and worked
at odd jobs for the Union Oil refinery until going to Stanford University
and graduating in 1895. Hired by Union Oil in 1899, he made the first
geological maps of California's most important oil fields.

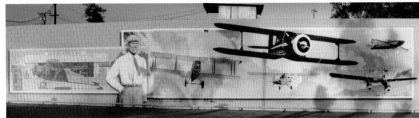

8. Celebrating Santa Paula's Artists and Architects *(left)*
136 N. Tenth Street, Wei Luan, 2004

Since the 1890s, Santa Paula has been home to many talented artists and architects. Among those honored in this mural are Douglas Shively, who specialized in local landscapes; Robert Clunie, known for his paintings of the Sierra Nevada; and Horace Bristol, a photographer who gained national recognition for his Depression-era photos. The figure on the left is the county's first architect, Roy C. Wilson, showing sketches for a local church to fellow architects Herman Anlauf, Robert Raymond, and John Stroh. The central figure holding a palette is Jesse Arms Botke (1883–1971), known for her lavish bird paintings. Her husband, Cornelis Botke (1887–1954), best known for his etchings, is shown adding finishing touches to the mural.

9. Honoring Founders and Pilots of Santa Paula Airport *(right)*
560 W. Main Street, Wendell Dowling, 2007

Ralph Dickenson, shown here, was the driving force behind the develop-ment of the Santa Paula Airport, which was dedicated on August 9, 1930. The six specific airplanes are just a sampling of the aircraft that used the airport. This unique airport also allows pilots to build, repair, reassemble, and fly experimental aircraft. Bill Hackbarth brought the remains of a 1918 De Haviland mail plane, which crashed in 1922, to the airport in 1965 to restore. Two years later, he flew the plane cross-country and donated it to the Smithsonian Institute.

OTHER THINGS TO DO

· Aviation Museum of Santa Paula: This unusual museum in a chain of hangars displays antique and experimental aircraft. Tours are available.

· California Oil Museum: Rotating exhibits of science, technology, transportation, history, and art complement the permanent display about petroleum.

· Santa Paula Train Depot and Railroad Plaza Park: The 1887 Southern Pacific Railroad Depot is headquarters of the Santa Paula Chamber of Commerce. Railroad Plaza Park features landscaped grounds and gardens, a gazebo, and a towering Moreton Bay fig tree dating to 1879. Train enthusiasts are welcomed aboard the antique Fillmore and Western Railway.

· Historic Homes: Santa Paula has thirty-one registered historic sites, more than any other city in Ventura County, representing many architectural styles. Four are open to the public: an 1890 oil com-pany headquarters, an 1895 Queen Anne home, a 1911 Craftsman hotel, and a 1917 community clubhouse. Maps are available at the chamber office.

· Los Padres National Forest: This rugged area is a popular destination for backpackers, hikers, anglers, and cyclists.

SANTA MARIA

(A mural town of the future, this town is in the early stages of becoming a mural town but worth a look if you are nearby.)

Santa Maria Valley Chamber of Commerce
614 S. Broadway, Santa Maria, CA 93454
(800) 331-3779
www.santamaria.com

In the mid–1800s, when California gained statehood, the rich soil of the Santa Maria area drew farmers and other settlers. Oil exploration began in 1888, and for the next eight decades, thousands of wells were drilled and put into production. The economy has remained focused on agriculture, and today the area is known for its vineyards.

The Santa Maria Mural Society is actively raising funds for a series of murals about the history and culture of the town.

The Santa Maria Mural

1: Cruisin' Broadway

1. Cruisin' Broadway *(next page)*
115 W. Chapel Street, Glenda Stevens, 2005
This mural depicts a section of South Broadway in the late 1940s and early 1950s.

OTHER THINGS TO DO

· Foxen Canyon Wine Trail: Travel this colorful route as it winds through the hills around Santa Maria and visit some of the wineries along the trail.

· Vandenberg Air Force Base: Visit the western missile-launching site of the U.S. Air Force.

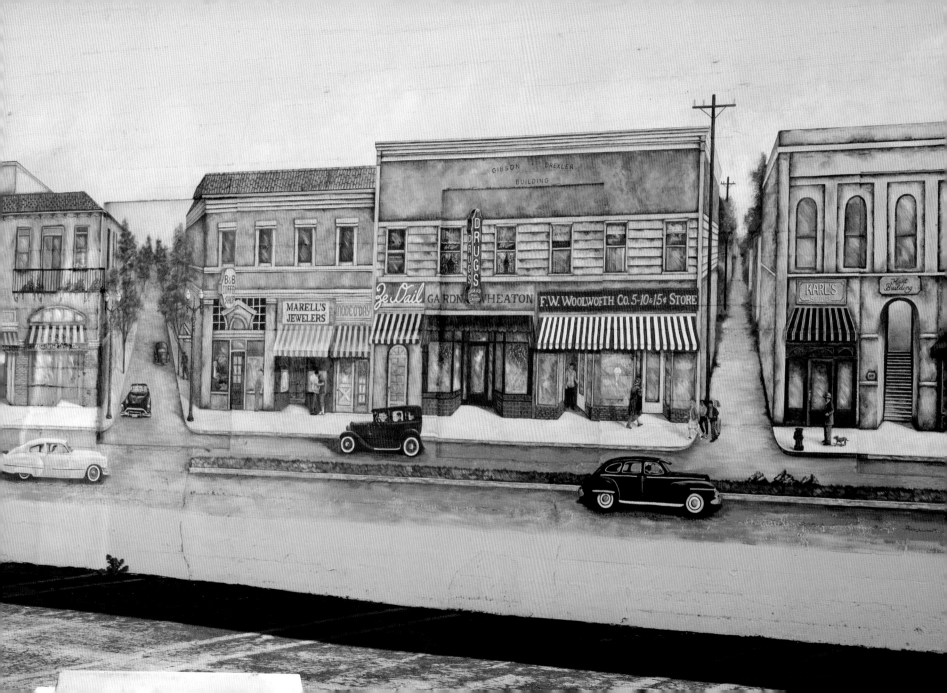

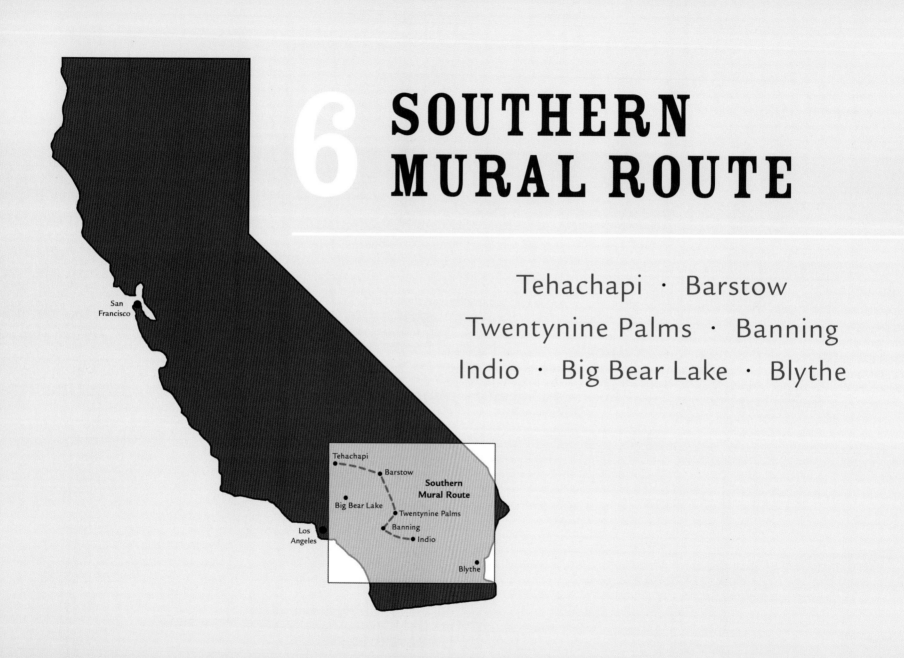

6 SOUTHERN MURAL ROUTE

Tehachapi · Barstow
Twentynine Palms · Banning
Indio · Big Bear Lake · Blythe

San Francisco

Tehachapi

Barstow

Southern Mural Route

Big Bear Lake

Twentynine Palms

Banning

Los Angeles

Indio

Blythe

TEHACHAPI

Chamber of Commerce
209 E. Tehachapi Boulevard, Tehachapi, CA 93581
(661) 822-4180
www.tehachapi.com

The discovery of gold in the Tehachapi region in the mid-1800s brought a wave of fortune seekers. Those who failed to strike gold often found land that they could claim under the Homestead Act, so they stayed, started ranches and farms, and raised families.

The railroad was what really put Tehachapi on the map. In 1876 the railroad connected San Francisco with Los Angeles via Tehachapi Pass, with its remarkable Tehachapi Loop. That same year the town was laid out by the Western Development Company, a division of the railroad.

The Tehachapi Murals

1: The Historic Tehachapi Loop
2: 1915 Street Dance
3: People of the Mountains: The Nüwa Tribe
4: T-hacha-P Brand
5: Red Front Blacksmith
6: Avelino Martinez

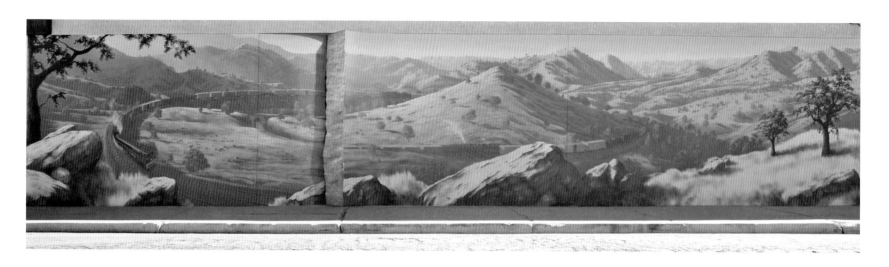

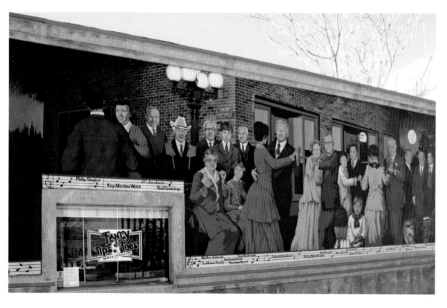

1. The Historic Tehachapi Loop *(top)*

228 W. Tehachapi Boulevard, John Pugh with Marc Spikerbosch, 2002

A trompe l'oeil effect creates the illusion of damage to the building from the 1952 earthquake, splitting the painting into two parts. The mural was Tehachapi's first.

2. 1915 Street Dance *(bottom)*

Tehachapi Boulevard across from Railroad Park, Phil Slagter, 2004

Phil Slagter drew on original photos to show a dance held when the first electric streetlights were installed in Tehachapi. In place of some of the people in the old photos, he used the faces of current residents and those from history.

3. People of the Mountains: The Nüwa Tribe *(top)*

F Street between Curry and Green Streets,
Colleen Mitchell-Veyna, 2004

The Nüwa tribe lived in the Tehachapi area. Portraits of
recent tribal members and elders, along with examples
of basketry, surround the historical village scene.

4. T-hacha-P Brand *(bottom)*

333 E. Tehachapi Boulevard, Art Mortimer, 2005

Jake Jacobsen, pictured, and his brother Rolf built the
seed-packing shed that now houses the Apple Shed
Restaurant. Jake Jacobsen served as mayor and is known
for many civic achievements. Fifteen Tehachapi artists
worked on this mural-in-a-day project.

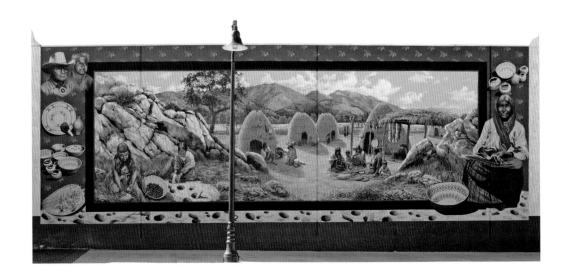

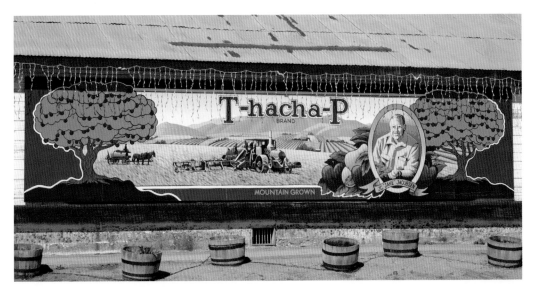

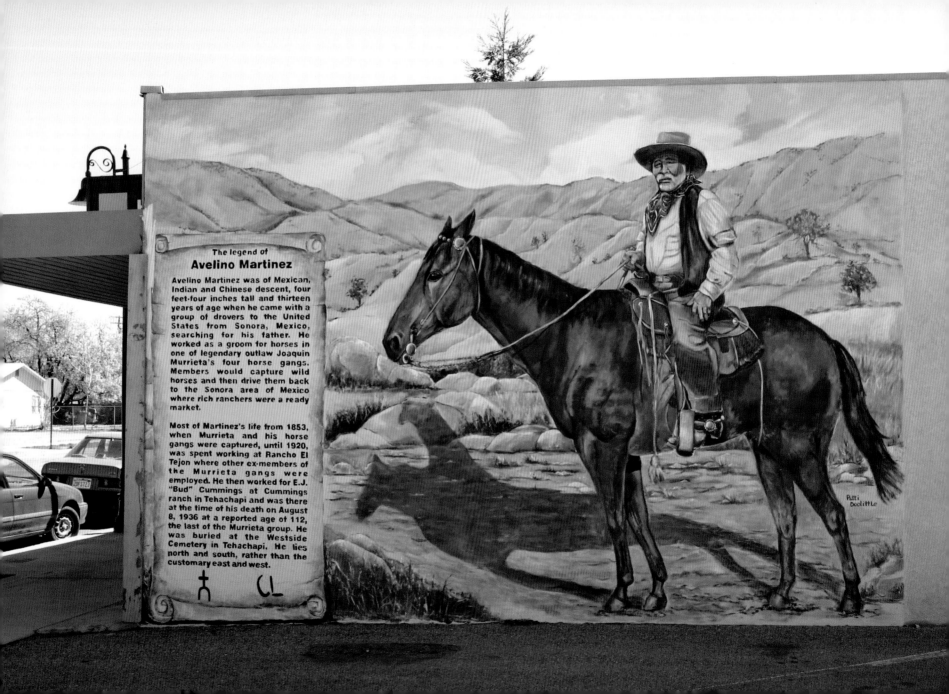

The legend of
Avelino Martinez

Avelino Martinez was of Mexican, Indian and Chinese descent, four feet-four inches tall and thirteen years of age when he came with a group of drovers to the United States from Sonora, Mexico, searching for his father. He worked as a groom for horses in one of legendary outlaw Joaquin Murrieta's four horse gangs. Members would capture wild horses and then drive them back to the Sonora area of Mexico where rich ranchers were a ready market.

Most of Martinez's life from 1853, when Murrieta and his horse gangs were captured, until 1920, was spent working at Rancho El Tejon where other ex-members of the Murrieta gangs were employed. He then worked for E.J. "Bud" Cummings at Cummings ranch in Tehachapi and was there at the time of his death on August 8, 1936 at a reported age of 112, the last of the Murrieta group. He was buried at the Westside Cemetery in Tehachapi. He lies north and south, rather than the customary east and west.

Patti Doolittle

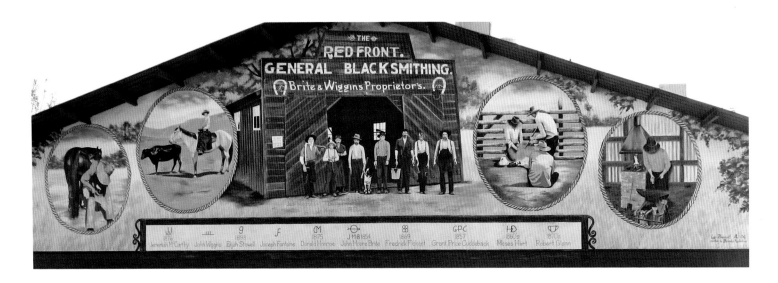

5. Red Front Blacksmith *(above)*

Curry and F Streets, Lyn Bennett, 2006

The original blacksmith shop was located across the street from this mural. The ovals show working blacksmiths and ranchers. All of the images were taken from old photographs.

6. Avelino Martinez *(previous page)*

126 E. F Street, Patti Doolittle, 2006

Martinez, who was of Mexican, Indian, and Chinese descent, arrived in the United States when he was a teenager and lived to be 112. For most of his life, he was a vaquero, ranch hand, and cook at the Tejon Ranch. Toward the end of his career until his death in 1936, he worked at the Cummings Ranch. Although only four feet, four inches tall, Martinez had a towering reputation and was respected throughout Kern County.

OTHER THINGS TO DO

- Mourning Cloak Ranch and Botanical Gardens: The thirty acres of landscaped gardens have more than 2,800 species of plants. Guided tours are available.

- Indian Point Ostrich Ranch: The working ranch occupies twenty acres in the mountains overlooking Cummings Valley. Tours educate the public about raising ostriches.

- Tehachapi Museum: The small building is filled with historical displays of material donated by local pioneer families.

- Tehachapi Loop: Just north of Tehachapi, the railroad from Bakersfield to Mojave makes a complete loop to climb the mountain. At this popular train-spotting location, you can photograph the locomotive and the tail of the train in the same picture.

BARSTOW

Barstow Area Chamber of Commerce and Visitor's Bureau
681 N. First Avenue, Barstow, CA 92311
(760) 256-8617 · www.barstowchamber.com

Main Street Murals
PO Box 1117, Barstow, CA 92312
(760) 257-1052 · www.mainstreetmurals.com

A desert oasis in the middle of the Mojave Desert, halfway between Los Angeles and Las Vegas, Barstow was immortalized in the song "Get Your Kicks on Route 66." Barstow began life as a railroad town and, in part, remains one today. William Barstow Strong, Santa Fe Railroad magnate, is the town's namesake. Just off Main Street, an old iron bridge leads to the railroad depot, once the site of the historic Harvey House, an inn opened in 1911.

Main Street, part of Historic Route 66, is the location of most of the town's murals.

The Barstow Murals

1: The Old National Trails
2: Three-Million-Dollar Harvey House
3: Waterman Junction Becomes Barstow
4: The Early Explorers
5: The Californian Gold Rush
6: General Beale Uses Camels
7: The Mormon Trail
8: The Old Spanish Trail of 1829–1848
9: Native American Voices from the Mojave Desert I
10: Native American Voices from the Mojave Desert II

1. The Old National Trails Highway *(next page)*
Main Street between Fifth and Sixth Avenues,
Jim Savoy with community volunteers, 1998

When families headed west to California in the early 1920s, they came via the Old National Trails Highway, which brought them to Barstow's Main Street. In 1926 the road became Route 66, also called the Mother Road. The mural has a six-foot jackrabbit. Main Street Murals, the Barstow mural society, sponsored a contest among elementary school students to name him. The winning name was Dusty Rusty, and an image of the jackrabbit can be found in every mural in the town, some hidden and others more clearly visible.

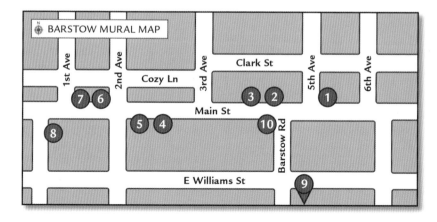

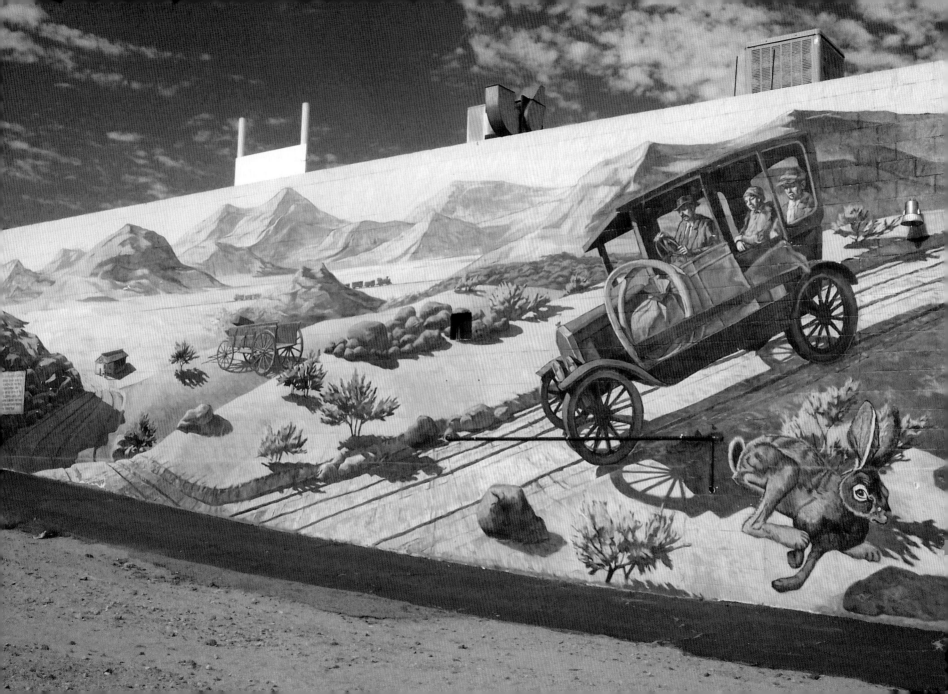

2 . Three-Million-Dollar Harvey House *(top)*
Fifth Avenue and Main Street, Kathy Fierro, 2003

From the late 1800s to the 1930s, when rail travel thrived, Fred Harvey set up a string of dining rooms and boarding houses for Santa Fe passengers. The Harvey House in Barstow, considered one of the jewels of the Harvey House system, offered gourmet cuisine served on fine china and drinks poured in crystal. The Harvey Girls served the meals and engaged travelers in friendly conversation.

3. Waterman Junction Becomes Barstow *(bottom)*
Main Street and Barstow Road, Kathy Fierro, 2004

In 1885 the California Southern Railroad Company connected with the Atlantic and Pacific Railroad line at the Mojave River to form Waterman Junction, named after the owner of the Waterman Mine. A post office was established in 1886, and the budding town of Waterman Junction was then named Barstow, honoring William Barstow Strong. This mural, the town's first mural-in-a-day project, involved about forty artists.

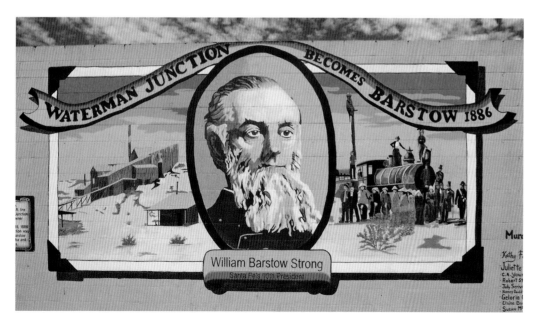

WATERMAN JUNCTION BECOMES BARSTOW 1886

William Barstow Strong
Santa Fe's 10th President

4. The Early Explorers

Main Street between Second and Third Avenues, Kathy Fierro, 2005

The mural consists of six portraits of early explorers.

4a. Father Garces 1738–1781 *(top left)*

In early 1776 Father Garces left the Yuma villages on the Colorado River and embarked on a journey that took him across the Mojave Desert to Mission San Gabriel. He was a master at finding Native American guides who would escort him through their lands.

4b. Jedidiah Smith 1798–1831 *(top right)*

In 1826 Jedidiah Smith led a party of seventeen men through the territory of the Mojave Indians across the desert, becoming the first European-Americans to enter California overland from the east. During the trek, the heat became so intense that they were forced to bury themselves in the sand to keep cool.

4c. John C. Frémont 1813–1890 *(bottom left)*

Frémont was noted for his bravery and his meticulous recorded notes on vegetation and geography. On his third expedition across California in 1845, he and Kit Carson led California pioneers in their rebellion against Mexico to gain independence.

4d. Christopher Houston "Kit Carson" 1809–1868 *(bottom right)*

During Carson's long and illustrious career, he was a trapper, guide, military scout, Indian agent, soldier, and rancher. He guided John C. Frémont across the west, and his feats are documented in Frémont's reports of his expeditions.

4e. General Steven Watts Kearney 1794–1848
(top left)

General Kearney, the father of the U.S. Cavalry, was named commander of the Army of the West by President Polk. In 1846 he brought one hundred men on an arduous trip from Santa Fe, New Mexico, across the Mojave Desert to California, where they did battle at San Pascal in the fight for independence from Mexico.

4f. Amiel Weeks Whipple 1817–1868 *(top right)*

Whipple's scouting expedition for a transcontinental railroad route crossed the Colorado River on February 27, 1854, and three weeks later reached Los Angeles, receiving aid from the Mojave Indians. The Atcheson, Topeka, and Santa Fe Railroad followed Whipple's trail for much of the way from Albuquerque to California.

5. The Californian Gold Rush *(bottom)*
Main Street between Second and Third Avenues, Kathy Fierro, 2006

This mural-in-a-day depicts how the California Gold Rush affected the town of Barstow by becoming the impetus for a railroad along the thirty-fifth parallel.

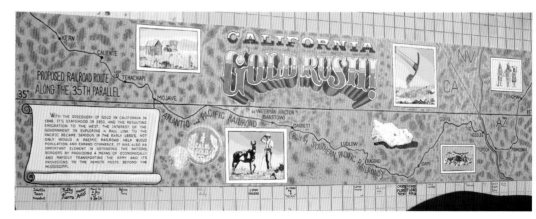

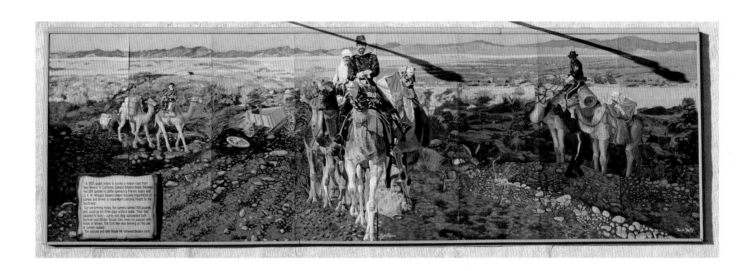

6. General Beale Uses Camels *(top)*

Main Street and Second Avenue, Kevin Varty with Kathy Fierro, 2000

In 1857, under orders to survey a wagon road from New Mexico to California, General Edward Beale imported camels and drivers to carry freight to the Southwest. Outperforming mules, the camels each carried seven hundred pounds and could go for three days without water. With the threat of the Civil War, the use of camels ended.

7. The Mormon Trail *(bottom)*

Main Street and First Avenue, Kathy Fierro, 2005

Members of the Church of Jesus Christ of Latter-day Saints traveled the 1,300-mile trail from 1846 to 1857. Church members helped paint this mural-in-a-day.

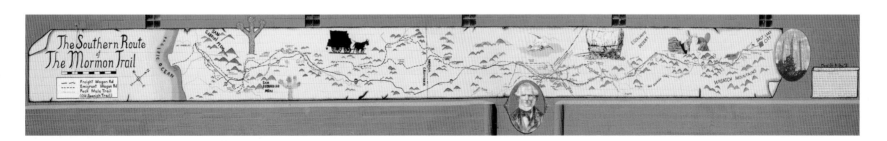

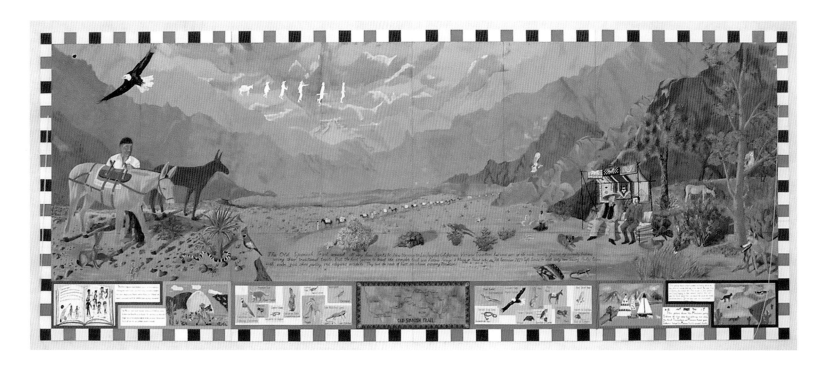

8. The Old Spanish Trail of 1829–1848 *(above)*

Main Street near First Avenue, David Brockhurst with Candice Michelson, Kathy Fierro, and Jane Laraman-Brockhurst, 2007

In 2007 Main Street Murals developed an educational program based on the Old Spanish Trail, involving schoolchildren and historical, cultural, and artistic groups from the community to help create murals. This mural-in-a-day was completed in time for presentation at the annual conference of the Old Spanish Trail Association, held in Barstow.

9. Native American Voices from the Mojave Desert I *(next page)*

24' x 10', Desert Discovery Center, 831 Barstow Road, David Brockhurst with Jane Laraman Brockhurst, Kathy Fierro, and local students, 2008

This mural, located in a garden patio, includes objects such as real tree branches and a three-dimensional bird that mirror their painted counterparts and heighten the scene's realism and depth. At the base of the mural are a fountain and stones adorned with Native American markings.

10. Native American Voices from the Mojave Desert II

72' x 10', corner of Barstow Road and Main Street, David Brockhurst with
Jane Laraman Brockhurst, Kathy Fierro, and local students, 2008

This mural is the second of two murals with the same theme and title.
They were conceived as part of an educational program with assistance
from local students. It depicts aspects of the lives of the Native Americans
who first populated the sparse and harsh landscape of the Mojave Desert.
Master muralist David Brockhurst poses in front of his creation.

OTHER THINGS TO DO

· Harvey House Museum Complex: At the Barstow Route 66
"Mother Road" Museum, you can learn the history of America's
fabled highway. At the Western Railroad Museum, you can explore
the history of the railroads in and around Barstow. The chamber
of commerce is also located in this historic building.

· Mojave National Preserve: Visit the sand dunes, volcanic cinder
cones, Joshua tree forests, and carpets of wildflowers, all found
at this 1.6 million acre park.

· Calico Ghost Town: Calico is one of the few remaining original
mining towns of the western United States. It was preserved by
Walter Knott (founder of Knott's Berry Farm and a relative of the
owner of Calico's Silver King mine).

· Walking Mural Tour: This walking tour of the Barstow murals
occurs on the last Saturday of every month. Visit the Main Street
Murals website for details.

TWENTYNINE PALMS

Action Council for 29 Palms
6455 Mesquite Avenue
Twentynine Palms, CA 92277
(760) 361-2286
www.oasisofmurals.org

The first recorded exploration of Twentynine Palms was made in 1855 by Colonel Henry Washington. He found Native Americans, principally from the Chemehuevi tribe, living in the hills and near a spring they called Mar-rah, meaning "land of little water." The spring, now the Oasis of Mara, is in Joshua Tree National Park.

The oasis was later used by gold miners, two of whom stated that their claim was a certain distance from "29 Palms Springs." A survey party counted twenty-six palms. Regardless, the early claim may well be the origin of the town's name.

After World War I, many returning veterans suffered from the effects of the mustard gas used in combat. Dr. James Luckie from Pasadena treated some of these men and in the 1920s began to search for an area in the desert that would provide a beneficial environment for people afflicted with respiratory and heart ailments. After visiting many places, he chose Twentynine Palms because of its moderate elevation and clean, dry air. Veterans brought their families and began homesteading the 160-acre parcels made available by the federal government.

The Twentynine Palms Murals

1: Desert Wildlife
 (no longer in existence)
2: Johnnie Hastie and the
 Twentynine Palms Stage
3: The Keys
4: Our Neighbors in Nature II
5: Desert Wildflowers
6: Operation Iraqi Freedom
7: Bill and Prudie Underhill
 and the Desert Trail
8: "The Flying Constable"
 Jack Cones
9: Valentine's Day
10: Good Times at
 Smith's Ranch
11: Flash Flood
12: Frank and Helen Bagley
 and the Bagley Store
13: The Sun Rises Mural
14: Dr. James B. Luckie,
 "The Father of
 Twentynine Palms"
15: Desert Storm
 Homecoming and
 Victory Parade
16: Early Life at the Oasis
 of Mara
17: Desert Gold Mining Days
18: The Dirty Sock Camp
19: William and Elizabeth
 Campbell
20: 29 Palms Boys
 Basketball Tournament

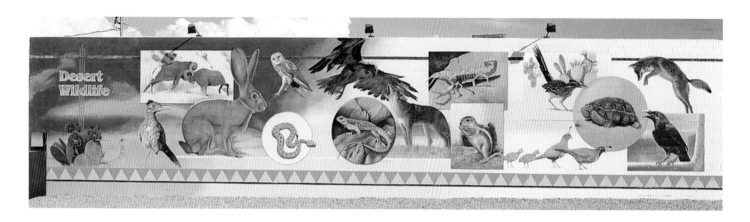

1. Desert Wildlife *(top)*

**50' x 14', no longer in existence,
Chuck Caplinger, 1999**

This mural portrays the wildlife of the high desert
and Joshua Tree National Park, including a coyote,
a roadrunner, a raven, a bighorn sheep, a desert
tortoise, and a family of quail.

2. Johnnie Hastie and the
Twentynine Palms Stage *(bottom)*

**32' x 13', 73339 29 Palms Highway,
Tim O'Connor, 1997**

Starting in 1938, Johnnie Hastie provided public
transportation from the high desert down to Palm
Springs. He built his first bus from a used 1928
Chevrolet truck. When Hastie retired in 1973, he had
driven more than seven million accident-free miles.

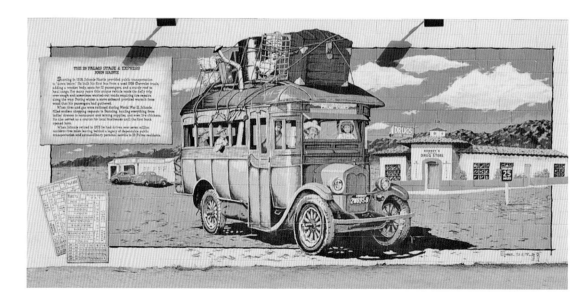

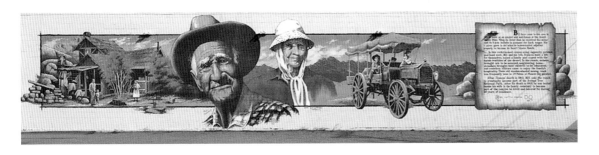

3. Bill and Frances Keys *(top)*

80' x 14', 29 Palms Highway at Pine Street,
Dan Sawatzky and Peter Sawatzky, 1994

The Keys were pioneer homesteaders who
settled at the Desert Queen Ranch in what
is now Joshua Tree National Park. Bill Keys,
born George Barth in Russia in 1879, came
to Twentynine Palms in 1910.

4. Our Neighbors in Nature II *(middle)*

86' x 13', 29 Palms Highway at Desert Queen,
Larry Eifert and Nancy Cherry Martin, 2006

This impressive lesson in desert ecology
highlights the wildlife found in and around
Twentynine Palms.

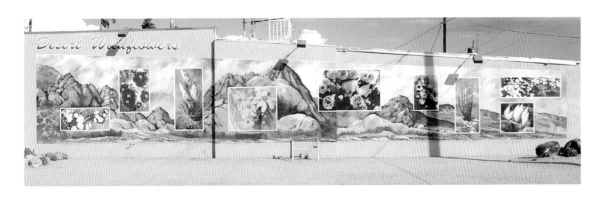

5. Desert Wildflowers *(bottom)*

60' x 12', Hart's Furniture, 73617 29 Palms
Highway, Dan Kelly, 2000

This, the third nature-themed mural in the
Oasis of Murals series, displays the wildflowers
of the Mojave Desert, set against a backdrop
of the giant rock outcroppings of Joshua Tree
National Park.

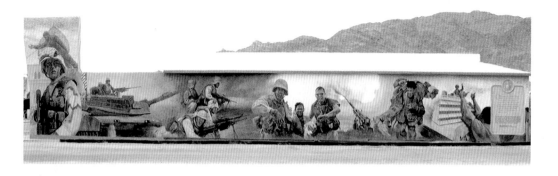

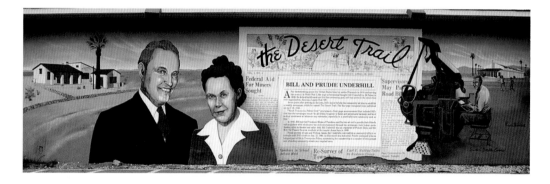

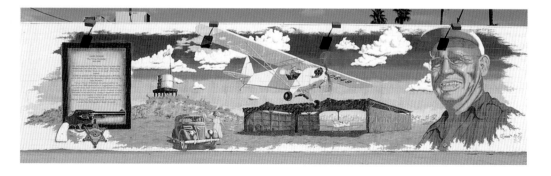

6. Operation Iraqi Freedom *(top)*
100' x 15–23', 6464 Adobe Road, Don Gray, 2004

The mural is dedicated to the men and women of the armed forces, especially the marines and sailors from the Marine Corps Combat Center in Twentynine Palms.

7. Bill and Prudie Underhill and the Desert Trail *(middle)*
40' x 10', 6396 Adobe Road, Susan Smith Evans, 1999

After he came to Twentynine Palms in 1928, Bill Underhill helped construct roads and the first public swimming pool. He also established a weekly newspaper, *The Desert Trail*. He and his wife, Prudie, built the town's first indoor movie theater, drive-in theater, and roller rink.

8. "The Flying Constable" Jack Cones *(bottom)*
60' x 16', 6308 Adobe Road, Tim O'Connor, 1996

Cones was elected constable of Twentynine Palms in 1932 and served until his death in 1960. He earned the nickname the Flying Constable by patrolling his 2,800-square-mile jurisdiction in a Piper J-3 Cub.

9. Valentine's Day *(next page)*
45' x 15', 6219 Adobe Road, John Pugh, 2000

The trompe l'oeil narrative tells the story of an artist who fell asleep while painting a mural. The rodeo bull, which looks as if it came out of the scene in the mural, is named Valentine for the white heart shape on his head. A vulture waits for the artist to wake up.

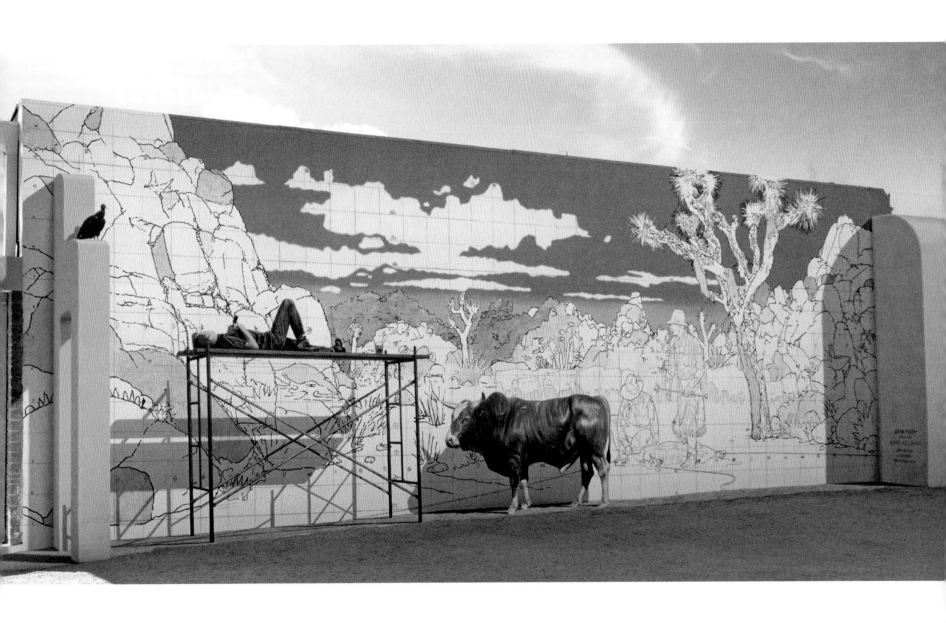

10. Good Times at Smith's Ranch (top)
100' x 14', 6298 Adobe Road,
Tim O'Connor, 2002

After homesteaders Bill and Thelma Smith married in 1930, they built an icehouse, a dairy, an ice-cream parlor, an outdoor theater, a recreational hall, and a trailer park on their property. They had six children and were acclaimed as the first homesteaders to have children born in Twentynine Palms.

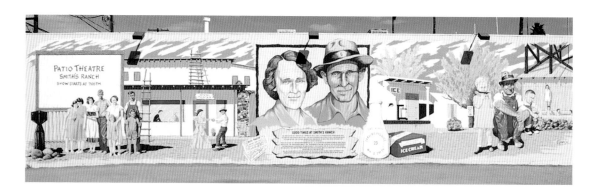

11. Flash Flood (middle)
40' x 18', 6248 Adobe Road, Art Mortimer, 1998

Before construction of a flood control channel in 1969, flash floods came down from 49 Palms Canyon, in what is now Joshua Tree National Park, through the center of downtown. This eighteen-by-forty-foot mural portrays, in a series of vignettes, the famous flash floods of the 1940s.

12. Frank and Helen Bagley and the Bagley Store (bottom)
100' x 12', 5653 Historic Plaza,
Dan and Janis Sawatzky, 1997

Homesteaders Frank and Helen Bagley arrived with their three sons on Thanksgiving Day, 1927. They set up house in a 324-square-foot garage, which they soon turned into the town's first general store. Bagley's Market, which contained a library and the town's first telephone switchboard, became the social center of the community.

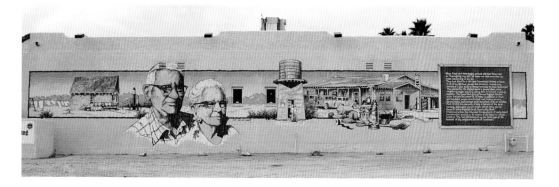

13. The Sun Rises Mural *(top)*

140' x 40', 6079 Adobe Road, Richard Wyatt, 2001

People came in cars and on horseback to Trig Hill for the first Easter Sunrise Services in the 1930s. In 1938 the service moved to the Twentynine Palms Oasis, then in 1978 to Fortynine Palms Canyon.

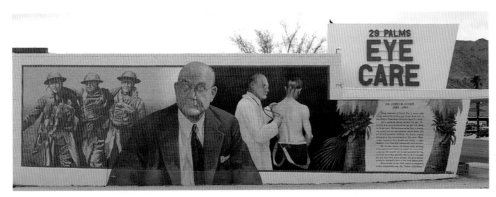

14. Dr. James B. Luckie, "The Father of Twentynine Palms" *(middle)*

50' x 17', 6175 Adobe Road, Don Gray, 1995

Dr. James Luckie, one of the town's early prominent citizens, brought ailing World War I veterans to the desert so they could experience the healing air. In this mural, he is flanked by scenes of World War I soldiers on the battlefield and of him treating a patient.

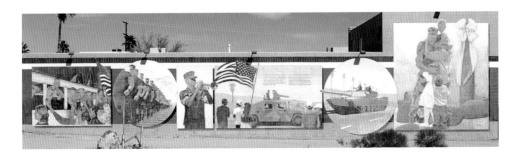

15. Desert Storm Homecoming and Victory Parade *(bottom)*

101' x 18', 6177 Adobe Road, Chuck Caplinger, 1995

The U.S. Marines, who established a base in Twentynine Palms in 1952, have served in many overseas missions. When the troops returned from the Persian Gulf in 1991, more than forty thousand people crowded the streets for a parade.

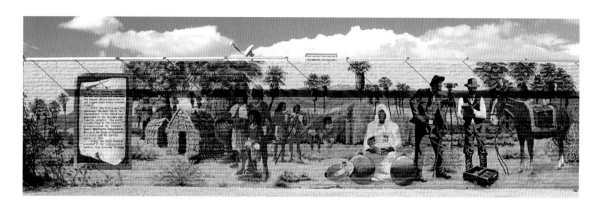

16. Early Life at the Oasis of Mara *(top)*

80' x 17', National Park Drive and
29 Palms Highway, Ron Croci and
Robert Caughlan, 1995

In this eighty-foot-long painting, Cahuilla Indians gather water at an oasis as a Cahuilla woman offers the exquisite the baskets for which the tribe was known. Next to her, Colonel Henry Washington and his assistant conduct a survey.

17. Desert Gold Mining Days *(bottom)*

30' x 8', Chamber of Commerce,
6455 Mesquite Avenue, Terry Waite
and John Whytock, 1998

Lifelong friends Oran Booth and Bill Keys prospected in the Twentynine Palms desert in the early 1900s. In 1933 Booth filed a claim on the eighty-acre homestead pictured here, where he built a cabin and dug a well by hand. Keys established more than thirty claims in the area that is now part of Joshua Tree National Park.

18. The Dirty Sock Camp *(top)*

40' x 14', 73911 29 Palms Highway,
John Whytock, 1996

Prospectors in the late 1800s set up camp
where water was plentiful. Dirty Sock Camp
was named for the miners' alternative method
of separating gold from mercury. According to
legend, when the requisite chamois leather
was unavailable, someone would sacrifice a
sock for the cause.

19. William and Elizabeth Campbell
(bottom)

80' x 14', 74017 29 Palms Highway,
Richard Wyatt, 1996

Bill and Elizabeth Campbell came to Twenty-
nine Palms in 1924 for World War I veteran
Bill's health. They homesteaded 160 acres,
where they built an exquisite home of native
stone, now a bed-and-breakfast called
Roughley Manor at Campbell Ranch. On
behalf of the Southwest Museum of Los
Angeles, the couple scoured the desert for
artifacts, logging thousands of finds.

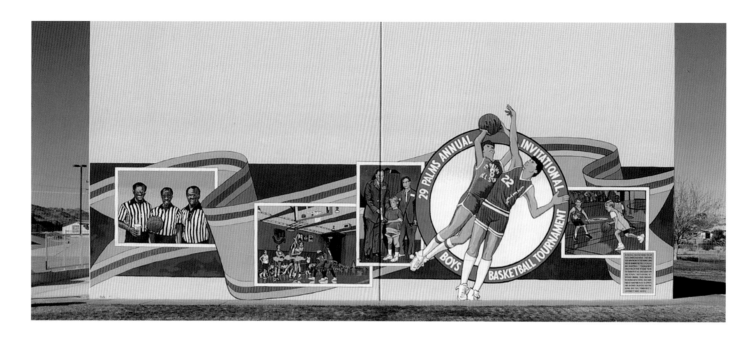

20. 29 Palms Boys Basketball Tournament

44' x 22', Joe Davis Drive and Utah Trail, Art Mortimer, 2002

For fifty years, the annual 29 Palms Boys Basketball Tournament, held in March, has attracted hundreds of competitors from California, Nevada, and Arizona. In 2002, for the forty-fourth tournament, a team of twenty-one local artists created this mural-in-a-day on the east wall of the handball courts in Luckie Park.

OTHER THINGS TO DO

· Joshua Tree National Park: Visitors can choose among a wide variety of activities: hiking, camping, bird-watching, bicycling, and rock climbing.

· Old Schoolhouse Historical Museum: This museum has displays and artifacts from the times of mining, cattle, and homesteading. Located on National Park Drive near the Oasis of Mara.

· 29 Palms Art Gallery: This community art gallery was founded in 1952.

BANNING

Banning Chamber of Commerce
123 E. Ramsey Street
Banning, CA 92220
(951) 849-4695
www.banningchamber.org

Banning Mural Council
175 W. Hays Street
Banning, CA 92220
www.banningmurals.org

Just before Interstate 10 east descends into the low desert, it passes by Banning. Known as Stagecoach Town USA, Banning served as a stage-coach and railroad stop between Arizona Territory and Los Angeles. The town is named after stagecoach owner Phineas Banning. Located in the historic part of town, the arts district features murals as well as galleries.

The Banning Murals

1: Banning Depot
2: Stagecoach Town USA
3: Stagecoach
4: Early California
5: America's Sweetheart
6: Banning Opera House
7: Western Floral

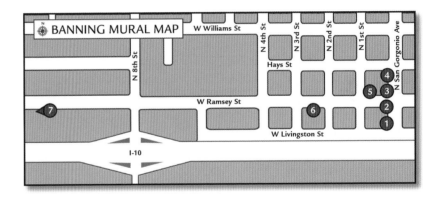

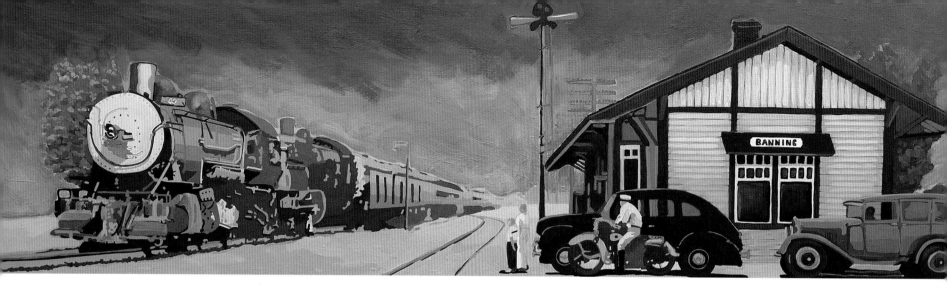

1. Banning Depot *(top)*

99 S. San Gorgonio Avenue, Kathy Boyer Talkington, 2003

The artist honors her late husband, Howard, who collected train memorabilia and worked for the Banning Police Department. Howard is depicted as the train engineer. The mural is on the Lithopass Printing building, near the location of the original Banning Depot.

2. Stagecoach Town USA *(bottom)*

42 W. Ramsey Street, Art Mortimer, 2004

The scenes from history show Banning's main streets, a stagecoach, and a girl with cherry trees in blossom, representing the town's agricultural heritage. The mural-in-a-day was dedicated to First Lieutenant Joshua Palmer, a Banning native who died in Iraq.

3. Stagecoach *(next page)*

41 W. Ramsey Street, Butch Murphy, 1995

The town's first mural depicts a stagecoach in Banning Pass, between two mountains, Mt. San Gorgonio and Mt. San Jacinto.

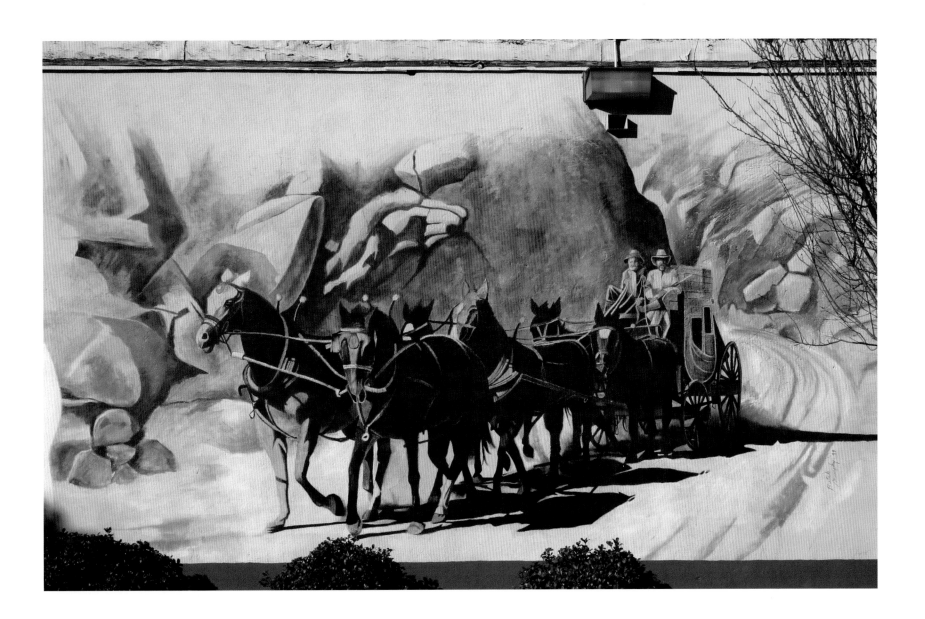

4. Early California *(top)*
89 N. San Gorgonio Avenue,
William "Ironhand" Swick, 2006

Local residents helped the artist paint this mural, which is based on Ironhand's memory of St. Boniface, a Catholic grammar school for Native American children destroyed by a fire in 1970. Ironhand cleverly incorporated the brickwork of the wall into the mural.

5. America's Sweetheart *(bottom)*
65 W. Ramsey Street,
Colleen Mitchell-Veyna, 2006

Pat Paul, now Pat Siva, was a rodeo trick rider and Hollywood movie stunt rider. She moved to the Banning area in the 1950s and became a successful businesswoman. The community participated in the painting of the mural.

6. Banning Opera House *(top)*

260 W. Ramsey Street, Carol Shetland, 2006

The mural takes the viewer back to the 1920s to the original Banning Opera House, which later became a movie theater. The building, later destroyed in a fire, was next to the famous Copland Building, a railroad-stop hotel.

7. Western Floral *(bottom)*

1434 W. Ramsey Street, Max West, 2000

Located on a wall of Decorating Addict Antiques, the mural is a fanciful rendering of the sights and colors of the desert.

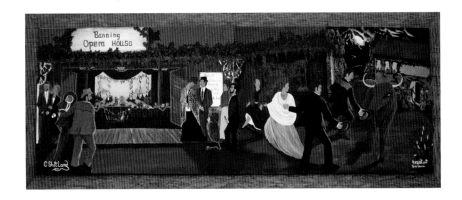

OTHER THINGS TO DO

· Gilman Historic Ranch and Wagon Museum: The museum interprets local history, including the culture of the Cahuilla Indians and the homestead ranch of James Marshall Gilman.

· Riverside County Regional Park and Open-Space District: This park features extensive hiking trails, picnic areas, and recreational activities.

INDIO

Indio Chamber of Commerce
82-921 Indio Boulevard, Indio, CA 92201
(760) 347-0676
www.indiochamber.org

The largest and oldest city in Coachella Valley, Indio is surrounded by mountain ranges topped with snow in winter. Two factors contributed to the growth of Indio, which was originally called Indian Wells. In 1879 the Southern Pacific Railroad selected Indio as a hub. Then, in the late 1800s, date palms began to be grown, eventually turning the area into a major date producer.

The Indio Murals

1: History of Transportation
2: Mary Ann's Bakery
3: Indio 300 Years Ago
4: The History of the Date Industry in the Coachella Valley
5: History of Electric Power in the East Coachella Valley
6: History of Agriculture in the Coachella Valley
7: History of Water in the Coachella Valley

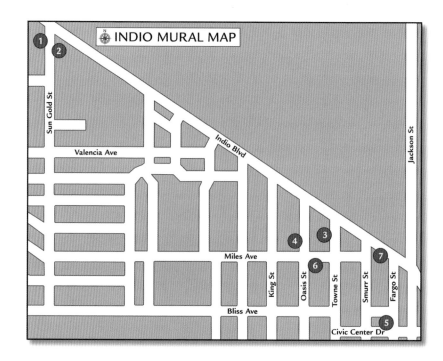

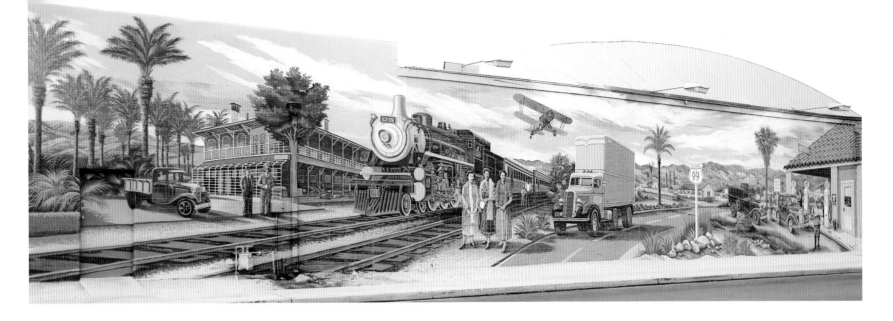

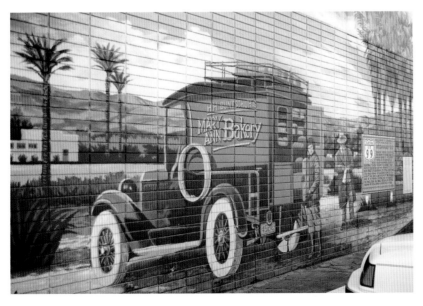

1. History of Transportation *(top)*
Indio Boulevard and Sun Gold Street, Duane Flatmo, 1996
This mural shows the various modes of transportation in the 1920s and 1930s.

2. Mary Ann's Bakery *(bottom)*
Indio Boulevard and Sun Gold Street, Duane Flatmo, 1996
Eureka muralist Duane Flatmo's first mural in Indio salutes a former area institution.

3. Indio 300 Years Ago *(previous page top)*

Indio Boulevard and Towne Street, Don Gray, 1997

This mural showing life in a Cahuilla Indian village in the 1700s, sponsored by the Cabazon Band of Mission Indians, is located just west of the original site of the ancient village.

4. The History of the Date Industry in the Coachella Valley
(previous page bottom)

Miles Avenue and Oasis Street, Chuck Caplinger, 1998

The local date industry began in the late 1800s with an experimental agriculture station. It blossomed into a thriving and profitable agricultural endeavor.

5. History of Electric Power in the East Coachella Valley *(above)*

Civic Center Drive and Fargo Street, Jim Fahnestock, 1999

This is one of three murals highlighting factors that made Indio an agricultural success. The others focus on water and transportation.

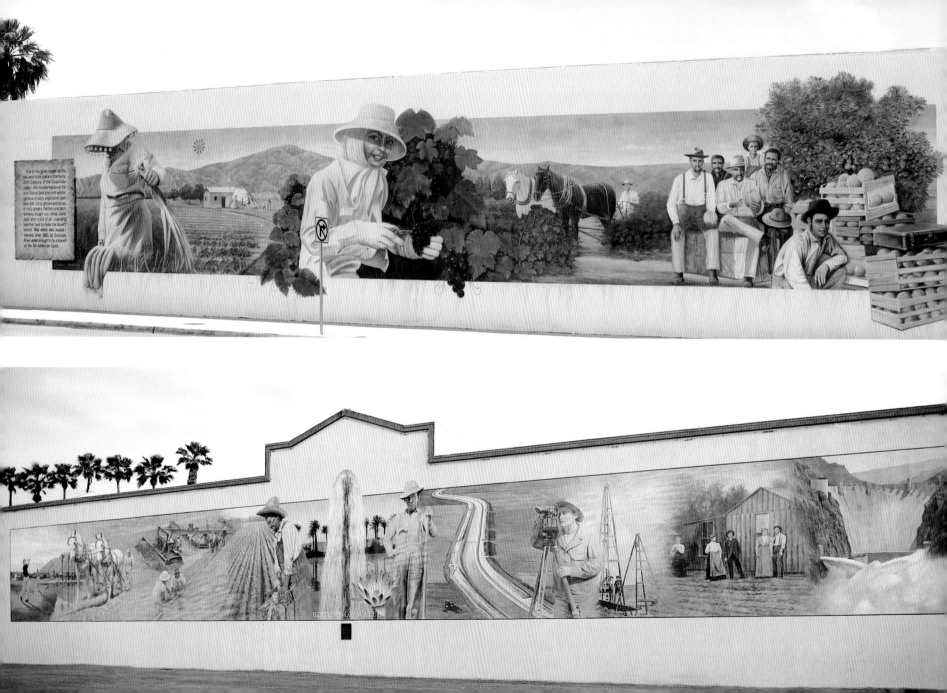

6. History of Agriculture in the Coachella Valley *(previous page top)*

Towne Street at Miles Avenue, Jim Fahnestock, 2001

Key crops grown in the Coachella Valley are singled out, including grapes and citrus.

7. History of Water in the Coachella Valley *(previous page bottom)*

Fargo Street near Indio Boulevard, Don Gray, 2003

The mural was sponsored by the family of Lowell Weeks, the first head of the Coachella Valley Water District.

OTHER THINGS TO DO

· Coachella Valley Museum and Cultural Center: The museum, in a 1926 adobe originally used as a doctor's office and home, honors local Native Americans and the area's pioneers.

· Coachella Valley Wild Bird Center: Injured and orphaned native birds are rehabilitated with the goal of returning as many as possible to the wild. Birds are on view, and the center gives bird walks.

· Cabazon Band of Mission Indians Cultural Museum: The museum displays artifacts and interpretive scenes of the Native Americans who inhabited the Coachella Valley.

· Salton Sea State Recreation Area: Salton Sea, actually a lake, is among the largest bird sanctuaries in the state.

· Palm Springs Air Museum: Military planes from World War II to present are on display.

· The Children's Discovery Museum of the Desert: Interactive exhibits are designed for children of all ages.

BIG BEAR LAKE

(A mural town of the future, this town is in the early stages of becoming a mural town but worth a look if you are nearby.)

Big Bear Chamber of Commerce
630 Bartlett Road
Big Bear Lake, CA 92315
(909) 866-4607
www.bigbearchamber.com

The Big Bear Lake Mural

1: Big Bear Lake

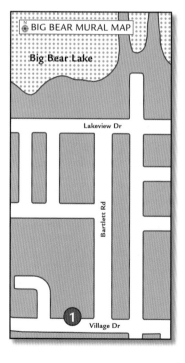

The actual Big Bear Lake was named for the numerous bears in the area by Benjamin Davis Wilson, who first visited in 1845. Wilson went on to become an important figure in southern California history. Among his accomplishments, he is remembered as the first mayor of Los Angeles, and he was responsible for the first railroad between Los Angeles and San Diego. Today Big Bear is a popular vacation spot. The Arts Council of Big Bear Valley is just getting started with its mural project but has plans for many more paintings in the future.

1. Big Bear Lake *(next page)*
8' x 7', Arts Council of Big Bear Valley Gallery,
40750 Village Drive, Lorin Z. Waldron, 2006
A seated figure watches both the muralist painting a mural of the lake and the mural of the lake.

OTHER THINGS TO DO

· The Big Bear Discovery Center: The center is run by the U.S. Forest Service and serves as an informational gateway to the area, with naturalist-led interpretive programs.

· Moonridge Animal Park: This interactive animal park features local animals from bears to eagles and has many educational displays.

· Big Bear Valley Historical Museum: This museum showcases the history of the Big Bear Valley.

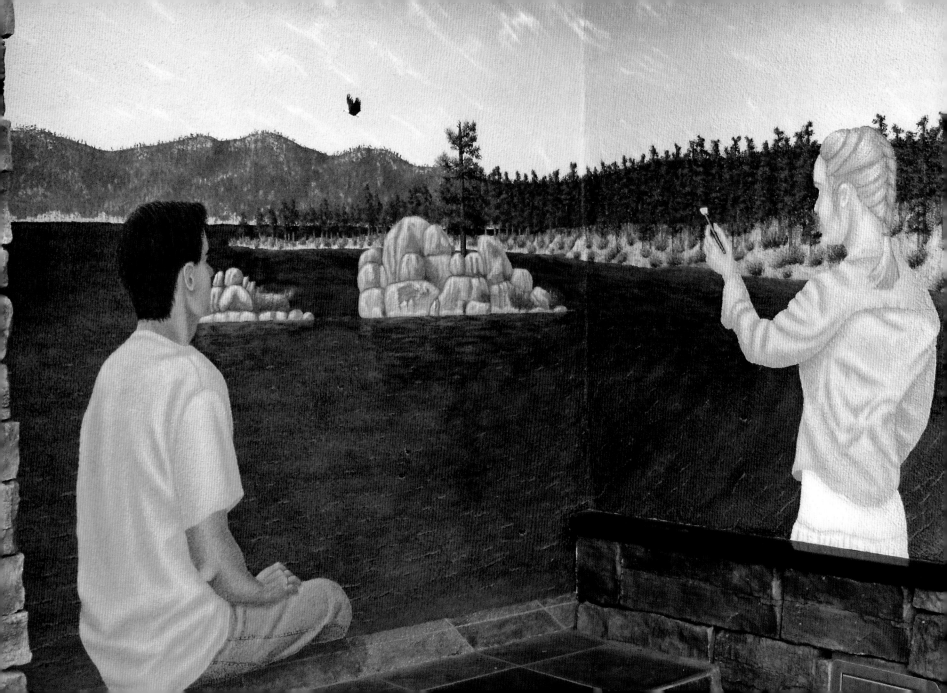

BLYTHE

(A mural town of the future, this town is in the early stages of becoming a mural town but worth a look if you are nearby.)

Blythe Area Chamber of Commerce
201 S. Broadway
Blythe, CA 92225
(760) 922-8166
www.blytheareachamberofcommerce.com

Blythe is jokingly said to be one hundred miles from *anything* but within two hundred miles of *everything*. This agricultural community located on the California-Arizona border was named after Thomas Blythe, a gold prospector who established primary water rights to the Colorado River in the region in 1877. The Blythe mural program is in its infancy but has made an auspicious beginning with a remarkable ceramic mural.

The Blythe Mural
1: Earthen

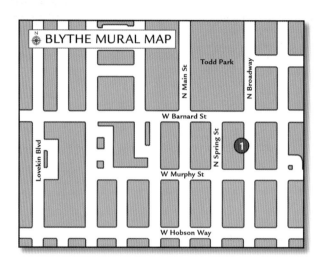

BLYTHE MURAL MAP

1. Earthen

11' x 17', Blythe City Hall, 235 N. Broadway, Joe Gaxiola, 2006

Represented are various features of the Palo Verde Valley: mountains, orchards, desert, and the Blythe intaglios (giant carved figures best seen from the air), tied together by the Colorado River and capped by the sky. The mural, a combination of original tiles and Venetian glass, was created by prison art facilitator Joe Gaxiola and fabricated by inmates at the Chuckawalla Valley State Prison. The tiles were hand set by Gaxiola and tile specialist Pat King.

OTHER THINGS TO DO

· Black History Museum and Cultural Society: This museum examines the contributions made by African Americans to the area.

· Palo Verde Valley Historical Museum: This museum covers the history of the area around Blythe.

· Fort Gaston Historical Museum: Viewers are invited to imagine what it would be like to have lived on a frontier fort.

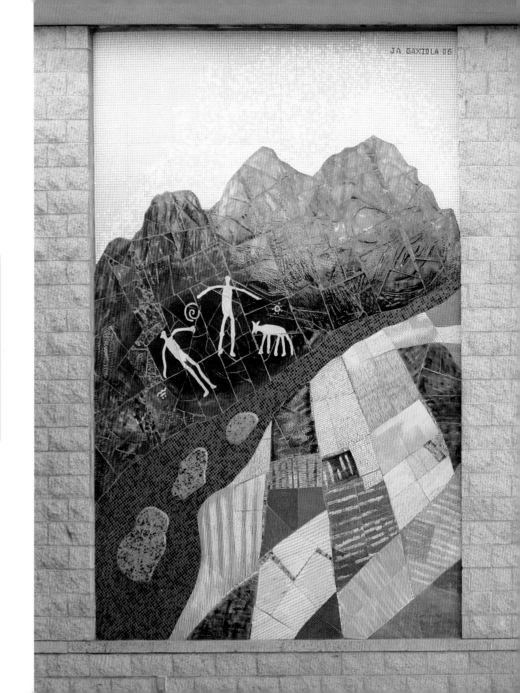

FURTHER MURAL TOWN EXPLORATIONS

For keeping up-to-date on the California small-town mural scene, the best source is CALPAMS (California Public Art and Mural Society; www.calpams.org). This remarkable association was created by the heads of mural societies in three of the state's most prolific mural towns: Bill Drennen of Lindsay, Gene Stevens of Lompoc, and Ray Kinsman of Twentynine Palms. CALPAMS sponsors the California Mural Symposium every other year. At the event, representatives from member towns and from towns considering a mural program discuss how to create and maintain a successful program. They also meet with artists, restorers, art historians, and manufacturers of art supplies, and discuss legislation and regulations that affect public art.

Other states have mural towns. A good source of information is http://people.hofstra.edu/faculty/Martha_J_Kreisel/murals_websites.html. A source for Canadian mural towns is www.mural routes.com. Information on international murals can be found at the Global Mural Arts and Cultural Tourism Association website: www.globalartsandtourism.net.

CREDITS

CRESCENT CITY: Photographs and adapted text reprinted with the permission of the Redwoods Mural Society.

Special thanks to Shirley Cook, Helga Burns, and the Crescent City/ Del Norte County Chamber of Commerce.

ARCATA: Photographs and adapted text reprinted with the permission of The Ink People Center for the Arts, Flatmo Graphics, Gene Joyce of the Arcata Exchange, Greg Gomes of Arcata Stationers, the City of Arcata, Phil Ricord of Wild-berries Marketplace, Melissa L. Zielinski and R. Paselk of the HSU Natural History Museum, and Leon R. Martin.

Special thanks to Pam Godwin, photographer, Libby Maynard, executive director of The Ink People Center for Arts, Heather Stevens, and Randal Mendosa, acting city manager, City of Arcata.

EUREKA: Photographs and adapted text reprinted with the permission of The Ink People Center for the Arts, Augustus Clark, Flatmo Graphics, Alme H. Allen III, Carroll Randall Spicer, and the Humboldt Arts Council

Special thanks to Sally Arnot, president of the Humboldt Arts Council, Libby Maynard, Shannon K. Taylor, Susan Bloch-Taylor, Richard Stenger, and Duane Flatmo.

FERNDALE: Photographs and adapted text reprinted with the permission of Daniel E. Crane Jr. of Gazebo, and Flatmo Graphics.

Special thanks to Dan Crane, president of the Ferndale Mural Society, Dan Tubbs, Photography and Design, and Duane Flatmo.

CHICO: Photographs and adapted text reprinted with the permission of John Pugh, Scott Teeple, William-Allen: Henderson/ EverOne, Gregg Payne, and Eric Grohe Murals & Design.

Mural by Gregg Payne 1996. Based on original photo by Ian MacMillian.

Special thanks to Mary Gardner, arts project coordinator of the City of Chico Arts Program, Brooks Thorlaksson for her input, and Dave Kilbourne for his sterling photographic efforts.

SUSANVILLE: Photographs and adapted text reprinted with the permission of the Lassen County Arts Council.

Special thanks to Douglas P. Sheehy, vice president of the Lassen County Arts Council, Ed Taves, president of the Lassen County Mural Society, and Ron Garrelts of Sudden Images Photography, photographer.

BISHOP: Photographs and adapted text reprinted with the permission of the Bishop Mural Society.

Special thanks to Andrea R. Shallcross, president of the Bishop Mural Society, Barbel Williams, past president of the Bishop Mural Society, and Karen Smith, photographer.

MANTECA: Photographs and adapted text reprinted with the permission of the Manteca Mural Society.

Special thanks to Norman C. Knodt, president of the Manteca Mural Society; and Linda Abeldt and Tom Wilson.

KINGSBURG: Photographs and adapted text reprinted with the permission of the Friends of the Kingsburg Library.

Special thanks to Maxine Olson.

LEMOORE: Photographs and adapted text reprinted with the permission of the Lemoore Chamber of Commerce.

Special thanks to Lynda Lahodny, CEO of the Lemoore Chamber of Commerce.

TULARE: Photographs and adapted text reprinted with the permission of the Tulare Cultural Arts Foundation.

Special thanks to Steve Presant, president of the Tulare Cultural Arts Foundation. All murals are dedicated to the City of Tulare and its residents.

EXETER: Photographs and adapted text reprinted with the permission of the Exeter Chamber of Commerce.

Special thanks to Sandra Blankenship, executive director of the Exeter Chamber of Commerce. The three entities responsible for the murals and the information included in the book are Exeter—A Festival of Arts, the City of Exeter, and the Exeter Chamber of Commerce. Thanks also to the late Seldon Kempton, who was a dedicated driving force behind the Exeter mural program.

LINDSAY: Photographs and adapted text reprinted with the permission of the Lindsay Mural and Public Arts Society.

Special thanks to Bill Drennen, president of CALPAMS, for his heroic efforts in bringing this book to fruition.

PORTERVILLE: Photographs and adapted text reprinted with the permission of the Porterville Art Association, Inc.

Special thanks to Vedra McElfresh, director of the Mural Project.

LOMPOC: Photographs and adapted text reprinted with the permission of the Lompoc Mural Society.

Special thanks to Vicki Andersen, Gene Stevens, and Lee Noose, photographer.

SANTA PAULA: Photographs and adapted text reprinted with the permission of the Murals of Santa Paula, a project of the Arts & Business Council of Santa Paula, a committee of the Santa Paula Community Fund, a nonprofit organization.

Special thanks to Joyce Carlson, president.

SANTA MARIA: Photographs and adapted text reprinted with the permission of the Santa Maria Mural Society.

Special thanks to Scott D. Anderson, president of Santa Maria Mural Society, and Jeannene Mitchell.

TEHACHAPI: Photographs and adapted text reprinted with the permission of Main Street Tehachapi Historical Murals.

Special thanks to Charles White, chairperson.

BARSTOW: Photographs and adapted text reprinted with the permission of Main St. Murals.

Special thanks to Jane Laraman Brockhurst, president of Main St. Murals and photographer for Off Limits Design, Inc., David Brockhurst, master mural artist of Off Limits Design, Inc., and prolific muralist Kathy Fierro.

TWENTYNINE PALMS: Photographs and adapted text reprinted with the permission of the Action Council for 29 Palms, Inc.

Special thanks to Eva and Ray Kinsman, coordinators, and Don Van Blaricon, photographer.

BANNING: Photographs and adapted text reprinted with the permission of the Banning Mural Council.

Special thanks to Claudia Keeling, founder.

INDIO: Photographs and adapted text reprinted with the permission of the Indio Chamber of Commerce.

Special thanks to Consuelo I. Marshall, Sherry Johnson, and Bruce W. Clark, founder of the Indio Mural Program.

BIG BEAR: Photographs and adapted text reprinted with the permission of the Arts Council of Big Bear Valley.

Special thanks to Gail M. McCarthy, executive director, and Lorin Waldron.

BLYTHE: Photographs and adapted text reprinted with the permission of the City of Blythe.

Special thanks to Chuck (Butch) Hull, assistant city manager.

ABOUT THE AUTHOR

Kevin Bruce is a native Californian born in San Francisco in 1941. He has been engaged in many professions, working variously as a musician, Russian interpreter, advertising copywriter, and real estate appraiser. He received a bachelor's degree in business from the University of Nebraska, Omaha, in 1968 and more recently a master of liberal arts degree from Stanford University. His master's thesis, based on the murals of John Pugh, evolved into his first book, *The Murals of John Pugh: Beyond Trompe L'oeil*, also published by Ten Speed Press. He is currently engaged as an art historian and author with a focus on chronicling the contemporary mural. He resides with his wife and fellow mural archivist, Pauline, in Berkeley, California, and Scottsdale, Arizona.